IMAGES
of America

TOVREA CASTLE

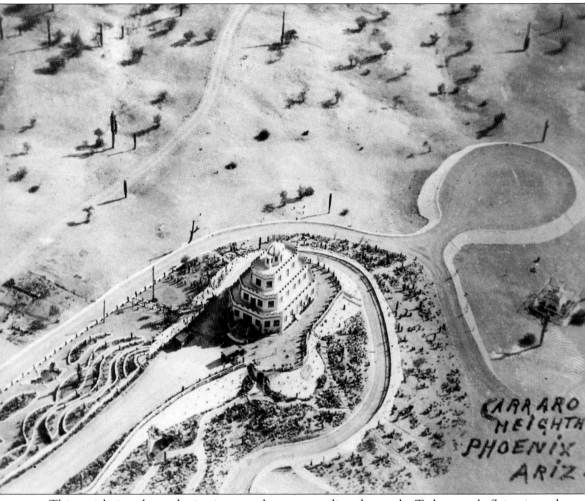

This aerial view shows the intricate gardens surrounding the castle. Today people flying in and out of Sky Harbor Airport will see denser vegetation around the castle and on the grounds. A dovecote, just above the writing Carraro Heights, was intended to house pigeons destined for the dining room table. (Courtesy of Marie Cunningham.)

ON THE COVER: From the northwest side of the castle, the neatly laid out cactus garden sets off the intriguing castle on the hill. Taken around the time of completion, 1930, this photograph gives the impression that a hotel was ready for guests. (Courtesy of Marie Cunningham.)

IMAGES
of America

TOVREA CASTLE

Donna J. Reiner and
John L. Jacquemart

ARCADIA
PUBLISHING

Published by Arcadia Publishing
Charleston, South Carolina

Printed in the United States of America

Library of Congress Control Number: 2010923457

For all general information, please contact Arcadia Publishing:
Telephone 843-853-2070
Fax 843-853-0044
E-mail sales@arcadiapublishing.com
For customer service and orders:
Toll-Free 1-888-313-2665

Visit us on the Internet at www.arcadiapublishing.com

To the dreamers who continue to come to Phoenix.
Sometimes you will be successful.

CONTENTS

Acknowledgments

We received tremendous assistance in finding photographs and documents related to Tovrea Castle from many people. And the more we told people that we were working on this project, the more photographs and stories came forth. The members of both families (Tovrea and Carraro) added the extra stories and details found in the captions that accompany photographs from their personal collections. The City of Phoenix Parks and Recreation Department and Historic Preservation Office provided a great deal of information related to the restoration project. Special thanks to Doris Lutes, Mark Lamm, Roger Lidman, Barbara Stocklin, and Kevin Weight, City of Phoenix employees dedicated to the dream of making Tovrea Castle a city park. Bill Jacobson, a retired city employee, kept fabulous records of the site during his years assigned to the project. Maria Hernandez in the Arizona Room at the Burton Barr Library ferreted out pictures when they were not where they should be. Tammy Parker from the City of Phoenix found people to identify cars. Don Mertes and Holly Heizenrader were invaluable when it came to making sure all our scans met the required parameters. Maureen Rooney was gracious to read the manuscript with a critical eye.

Ultimately our thanks go out to the residents of Phoenix and the Valley of the Sun who saw the need to save this historic building and were willing to pass several bond elections, raise money, and volunteer so that Tovrea Castle would be preserved for future generations.

All images from the *Arizona Republic* are used with permission. Permission does not imply endorsement.

INTRODUCTION

This volume of the Images of America series explores the dreams of several people who came to Arizona from the late 1800s through the late 1920s and eventually settled in Phoenix. The manifestation of their dreams was a uniquely shaped structure that the locals describe as the "wedding cake" building, but whose proper name on the City of Phoenix Historic Register and the National Register of Historic Places is Tovrea Castle. Each of the people and families involved with Tovrea Castle and this site has a remarkable and different story. The stories intersect at different times over the years, personally and historically, and make for interesting reading. And in some respects, these stories reflect the history of Phoenix, Arizona, itself as well as the late territorial days of Arizona and the early days of Arizona statehood. Simply put, the multiple layers of Phoenix history—early homesteading, immigrants, resorts, and cattle barons—plus the unusual topography all come together at Tovrea Castle.

Arizona, a mixture of rugged mountains and vast desert lands, became a part of the United States following the War of 1848. It officially became a territory in February 1863 and the 48th state on February 14, 1912. Most people, however, do not realize that the settlement that eventually became Phoenix dates from 1868, after the Civil War. So while the city is located in the Southwest, it has no Spanish Colonial roots. Nevertheless, like the mythical Phoenix bird, the proud city of Phoenix rises from the ruins of the ancient Hohokam civilization.

The spectacular land of Arizona has attracted people for a number of reasons ever since the Spaniards first explored the area in the mid-1500s. Prior to the American Civil War, some came with hopes of gaining wealth through mining gold and silver. The mountainous regions lured trappers. Following the Civil War, many Southerners came seeking a place to perhaps escape the devastation of the South. Northerners came as well, for Arizona offered a place where these individuals and families might have a fresh start, since the Homestead Act of 1862 meant they could acquire 160 acres. For many who decided to venture out West, this amount of acreage was far more than they had back home. By the turn of the 19th century, others came at the advice of their doctors to seek a dry climate for various respiratory or other health conditions.

The distinction as the last state of the lower 48 (the "baby state"), a place previously known for its Indians and gunfights, was just part of the story and intrigue. Arizona had an aura that acted as a magnet for people, particularly those who lived in the East or Midwest. The business leaders in Phoenix, however, recognized the area's potential as a vacation spot for the upper middle class and wealthy as early as the late 1880s. The Phoenix Chamber of Commerce organized in November 1888. Thus boosterism became a way of life in Phoenix, and more hotels catered to the influx of visitors. Whatever the reason, though, the people who came to Phoenix had dreams and saw Arizona as a place where they might achieve them. By 1900, the Phoenix census confirmed the population had reached 5,500 people, all in a little over 30 years.

The growth of Phoenix, now the fifth-largest city in the United States, relied on a number of factors, but certainly the availability of water was and still is central to all. This valuable resource

enabled farmers to grow crops that the railroads sent to various markets or to raise enormous herds of cattle. The greening of the desert attracted more people. How was it possible to live in a hot desert? One had to come and see. Once they came, they told their friends and relatives about the fabulous opportunities. More people traveling to the area, whether visitors or ultimately residents, resulted in new buildings. With the advent of air conditioning in homes in the early 1950s, and the opportunity to buy cheap land as well as inexpensive homes, even more people flocked to Phoenix. And the construction attracted more people as the cycle continued.

Prominently situated atop an unusual granite outcropping, Tovrea Castle is an instant curiosity visible from surrounding roads and from planes landing and taking off at nearby Sky Harbor Airport. For years, area residents and tourists have wondered about the mustard-colored wedding cake landmark with its cupola and battlement parapets. It is the number one building people ask about when first arriving at the airport, wondering who lived there and what the inside is like. Because Tovrea Castle was always a private residence with few visitors, the stories connected to this mysterious building grew. People wondered why were there tunnels, and whether rumors about mobsters and gambling activities were true.

Now owned by the City of Phoenix, this curious building is the focal point in what will be a 44-acre city park. Increased interest and wonderment occurs with the current limited public access for Saturday garden tours during the cooler months of the year. A limited number of people come close to the castle through the garden tours, but not inside it or the other historic outbuildings as the restoration process continued.

The history of Tovrea Castle not only speaks to the time it was constructed, the late 1920s, but also connects to the troubling economic times of the early 21st century. The booms and depressions of these years impacted not only the lives of those who built the castle, but the City of Phoenix's current attempt to protect and restore the castle as part of its park system so it can remain a treasured icon in the continuing history of the area.

The chronology of this historic place enables the reader to see connections between the lives we lead today and the lives that once created this landscape and unusual building. Ultimately, the understanding of the importance of this place leads to the consciousness of the power, purpose, and value of preservation of historical and cultural resources for now and future generations.

One

AN OASIS IN THE DESERT

The story behind the founding and naming of Phoenix varies. Historians do agree that farming began along the Salt River not long after the establishment of Camp McDowell, located on the west bank of the Verde River, in 1865. By 1870, Jack Swilling, William Hancock, Darrell Duppa, and other area pioneers selected a half-square-mile town site that would become Phoenix. The Hancock survey of this site created 96 blocks with the east/west streets named after the country's presidents and the north/south streets named after Arizona Indian tribes. By the 1890s, these Indian names were replaced with numbered streets to the east side of Center Street (now Central Avenue) and numbered avenues to the west.

On February 25, 1881, the City of Phoenix incorporated as a result of the passage of the Phoenix Charter Bill in the 11th Territorial Legislature. Following the arrival of the Southern Pacific Railroad on July 4, 1887, the community was able to start transforming itself to look much like the places the residents had come from. Adobe homes became brick. Commercial buildings did too. In 1889, Phoenix became the capital of the Arizona Territory, which set the stage for its present prominence within the state and eventually the country.

Water, one of the most important commodities in a desert, became secure with the construction of the Roosevelt Dam on the upper Salt River. The water flowing through the established canals enabled the small farming community of Phoenix, along with other similar communities in the Salt River Valley, to flourish. The hardy residents, though, still had to figure out how to deal with the oppressive summer heat. Although many left Phoenix during July and August, those who stayed behind became quite creative. Near sundown, backyards and screened porches became gathering spots with much of the dinner meal cooked and eaten outdoors. Families usually slept together on screened porches at the back of houses, in the yard, and sometimes on rooftops. Phoenix's irrigation canals and ditches provided recreation areas for everyone.

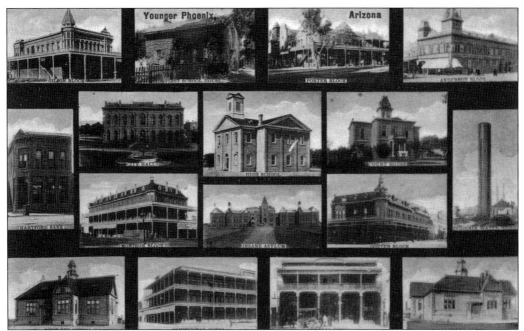

Maricopa County, the fifth formed in the Arizona Territory, was created from portions of Yavapai and Pima Counties on February 14, 1871. Phoenix became the county seat. By 1887, Phoenix boasted a number of substantial buildings (above), including schools, hotels, retail blocks, several banks, a formidable courthouse and city hall, as well as the state insane asylum. The Adams Hotel was one of many hotels built to accommodate the influx of tourists and visitors who came to Phoenix. It was grand and luxurious for the time and probably amazed the Easterners who might not have expected such elegant lodgings. (Both, courtesy of the McClintock Collection, Phoenix Public Library.)

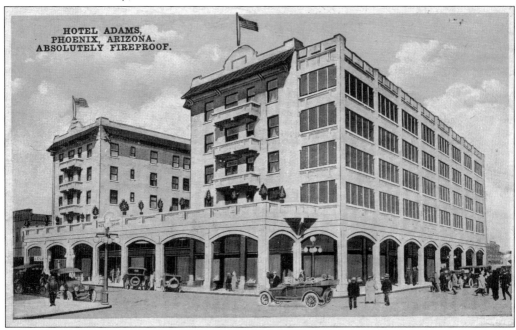

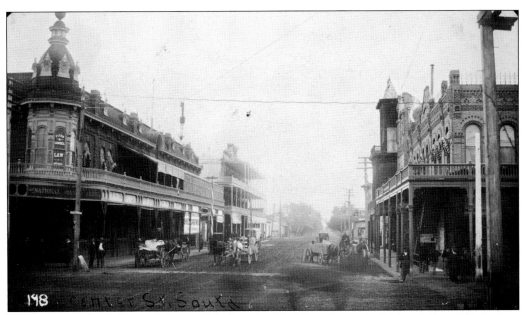

Center Street (now Central Avenue) looking south (above) was similar to many major streets in the West. It had boardwalks to walk on and building arcades to protect pedestrians from the blistering sun, driving rains and dusty or muddy roadways. Buildings were multi-storied with larger businesses on the ground floor and smaller offices on the upper levels. Horse-driven wagons brought crops to market and hauled goods back to homes or farms. The bird's-eye view below shows taller buildings increasingly constructed of stone and brick as those materials became more readily available once the railroad came to Phoenix. The electric lines and light poles indicate that Phoenix provided many of the comforts people wanted, even despite the crude dirt streets. (Both, courtesy of the McClintock Collection, Phoenix Public Library.)

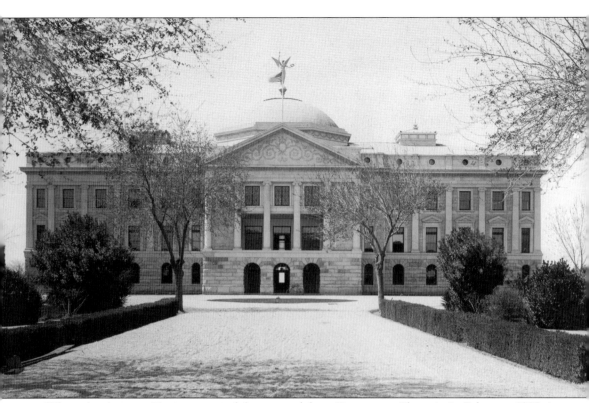

When the Arizona Territory capital first moved from Prescott to Phoenix in February 1889, it had no permanent building. Although the City of Phoenix agreed to pay for the capital's move, initially the government had temporary offices in the new Phoenix City Hall. The ultimate site was to be in State House Park on Seventeenth Avenue between Jefferson and Adams Streets. By 1897, the 19th Territorial Legislature issued $100,000 in Congressional-approved bonds to build a permanent building for the growing offices of the territorial government. The 20th Territorial Legislature helped with an additional $30,000. This impressive building, designed by James Riely Gordon from San Antonio, Texas, used primarily Arizona materials. The Malapai rock came from nearby Camelback Mountain and the granite from South Mountain. The tufa stone came from Yavapai County. The building was dedicated on February 25, 1901. Upon statehood in 1912, the territorial capitol became the state capitol. Placed on the National Register of Historic Places in 1974, the building was restored to its 1912 grandeur in 1981. (Courtesy of the McClintock Collection, Phoenix Public Library.)

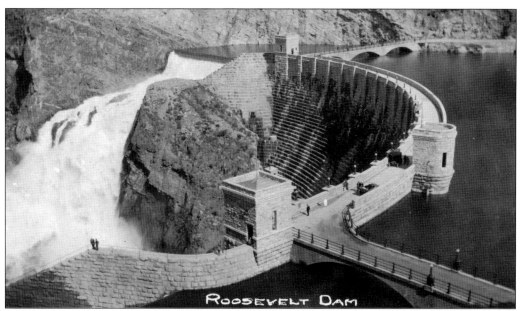

Prior to the construction of Roosevelt Dam, Phoenix was subject to devastating floods and droughts. The Roosevelt Dam (above), once the largest masonry dam and one of the first projects funded by the National Reclamation Act of 1902, provided a reliable water source and flood control for Phoenix and other parts of the Salt River Valley. Originally called the Tonto Basin Dam, it officially became the Theodore Roosevelt Dam when former president Theodore Roosevelt dedicated it May 5, 1911. The Crosscut Canal (below) was, and still is, part of the vast gravity-driven irrigation system that helps disperse the water stored behind Roosevelt Dam to the farmers and residents of Phoenix and other communities in the valley. The Salt River Project irrigation system partially mirrors canals constructed by the Hohokam centuries earlier. (Both, courtesy of the McClintock Collection, Phoenix Public Library.)

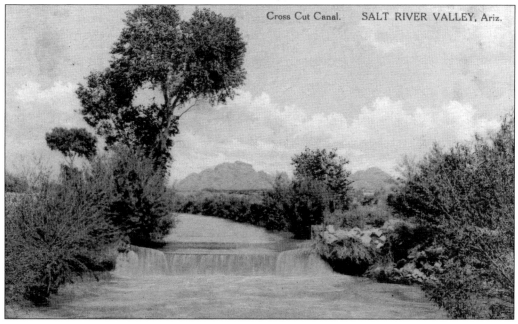

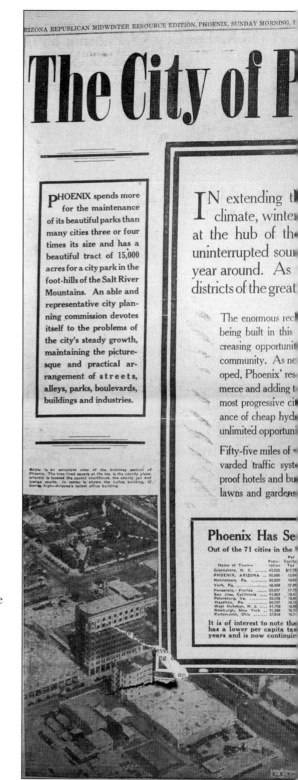

The city of Phoenix opened its arms to newcomers and tourists, actively beckoning those who lived in cold climes. The December 26, 1926, mid-winter edition of the *Arizona Republican* provided all the reasons why someone should come to visit and/or remain permanently: low tax rates, paved roads, lush vegetation, a variety of recreation and cultural places, and great weather. Who would not want to come when temperatures were below freezing in the East and Midwest and comparatively mild in Phoenix? There is no doubt that visitors came as more resort hotels opened. Promotional materials never mentioned the high summer temperatures. (Courtesy of the *Arizona Republic*.)

enix Invites You!

Above is an aeroplane view of the Phoenix cit plaza. Fire station No. 1 is shown in the low

hand of sincere welcome, Phoenix is inviting you to a city of incomparable
and roses, scenic splendo and metropolitan comforts and advantages. Situated
and most fertile irriga agricultural area in the world, Phoenix enjoys an
table business from the diversified crops produced in the surrounding valley the
iting center of the entire state and the source of supply for the immense mining
t, this city is a business community of substantial magnitude and consistent growth.

ower development programs, no creational, cultural and social facilities of the finest type --- all
intry, are creating constantly in- combine to make Phoenix a beautiful, comfortable, healthful and en-
on of service and growth for this joyable city in which to live, work, play and prosper. Completely
aimed and new industries devel- motorized street cleaning equipment keep the streets and alleys free
ace, constantly increasing our com- from dirt and dust; modern motorized fire-fighting apparatus pro-
nctions which go to make this th ct the homes and buildings of the city and efficient, uniformed
the entire Southwest. An abund- police protect the person and property of our people.
er, now available, offers industry
ley.

The figures compiled by the National Safety Council show that of all
the cities of the United States, with populations from 30,000 to 50,-
dern electric lighted streets, bou 000, the average fatal accidents from automobiles is 350 per cent
arterial highways, modern fire- greater than that of Phoenix, notwithstanding the fact that the per
beautiful es surrounded w pita ownership of automobiles in Phoenix is about one to every four
nd flowering shrubs, educational, persons.

Besides its many other advanta
Phoenix has a water supply tha
second to one, both in point
purity and dependability of sup
Piped from the Verde River,
miles away, and having its so
in the San Francisco Peaks a
elevation of over 12,000 feet
pure soft water flows by gra
into the homes, offices, hotels,
business institutions of the city.
5,000,000-gallon reservoir, near
city, insures the uninterrup
service from this source of s
ply. The following analysis she
the purity of its content:

ANALYSIS OF CITY OF PHOENIX
WATER SUPPLY

By John C. Sparks, Chemist, New York
Parts per 100,000

Total Solids	35
Mineral Matter	2
Organic and Volatile	9
Free Ammonia	0
Albuminoid Ammonia	0
Nitrogen as Nitrate	0
Nitrogen as Nitrite	0
Odor	0
Appearance	0

Mineral Matter

Calcium Carbonate	15
Magnesium Carbonate	3
Sodium sulphate	3
Sodium chloride	0.5
Silica	0.5
Alumina	0.0
Oxide of Iron	0.0

From the report of J. B. Lippincott, Consult
Engineer, Los Angeles, California, on
Phoenix City Water Supply, dated July 1
1922: "This is an unusually pure wat
for the arid regions of the Southwest and
well within general standards accepted
Water Work authorities. It is of about
same quality as that obtained by the City
Los Angeles from the Sierra Nevadas, throu
their aqueduct somewhat better than is
in San Francisco and much similar to
supply at Pasadena."

From 236-report of New York City an
Phoenix City Water Supply:

"I do not recall that the Verde water
materially surpassed by any supply with
knowledge elsewhere throughout the country

st Per Capita Tax Rate of 71 Cities Between 30,000 and 50,000 In the U.S.

h populations between 30,000 and 50, has next to the lowest per capita tax rate, as shown by the following tables:

Popu-lation	Capita Tax	Name of Town	Popu-lation	Capita Tax	Name of Town	Popu-lation	Per Tax	Name of Town	Popu-lation	Per Tax	Name of Town	Popu-lation	Per Capita Tax
		Ogden, Utah	35,201	30.31				Fitchburg, Mass.	42,155	30.31	Lorain, Ohio	40,527	32.85
43,058	19.84	Name of Town	lation	Tax	Joliet, Ill.	38,801	25.27	Oshkosh, Wisconsin	33,197	30.41	Medford, Mass.	44,782	33.15
35,065	19.87	Decatur, Illinois	47,795	22.53	Muncie, Indiana	40,321	25.21	Muskogee, Oklahoma	31,312	30.83	Cedar Rapids, Iowa	45,177	33.25
41,762	20.57	Moline, Illinois	32,521	22.44	Chicopee, Mass.	40,912	25.67	Waterloo, Iowa	35,930	30.86	Salem, Mass.	42,529	33.57
48,355	20.20	Aurora, Illinois	38,051	22.82	East Chicago, Indiana	35,720	25.77	East Chicago, Indiana	42,064	31.21	Waltham, Mass.	32,051	34.26
88,314	20.35	Amsterdam, New York	34,356	23.26	Easton, Pa.	34,000	27.35	Sheboygan, Wisconsin	32,245	31.40	Hammond, Indiana	48,508	36.15
37,625	20.58	Poughkeepsie, N. Y.	37,645	24.10	New Brunswick, N. J.	35,192	27.41	Green Bay, Wisconsin	35,100	31.96	Newport, Rhode Island	31,374	36.57
36,045	21.04	Watertown, New York	32,898	24.17	Perth Amboy, N. A.	38,323	28.40	Bay City, Mich.	48,292	31.44	Pontiac, Michigan	40,034	40.08
54,665	21.11	Austin, Texas	36,083	24.61	Dubuque, Iowa	42,611	28.65	Chelsea, Mass.	47,062	31.51	Mount Vernon, N. Y.	45,171	42.54
44,757	21.28	Taunton, Mass.	38,148		Battle Creek, Mass.	36,350	28.74	Kenosha, Wisconsin	46,682	32.05	Brookline, Mass.	47,336	45.11
48,257	22.04	Waco, Texas	40,908		Battle Creek, Mass.	28,60	Wisconsin	34,021	32.59	Newton, Mass.	48,205	48.88	
38,407	22.06	Elmira, New York	48,354		old, Mass.	45,200	29.03	Muskegon, Michigan	40,718	32.78	New Rochelle, N. Y.	35,880	57.78
46,802	22.24	Orange, New Jersey	34,629		on, Ohio	41,408	29.57						

ten times as much for its Library Fund and ice as much for Recreation Funds as Greensboro, N. C., which is the only city that
x. Notwithstanding the constant extens and improvement of its services, the City of Phoenix lowered its tax rate for two
tely low rate shown in the above table

Its to this modern city of sunshine, warmth, beauty and charm,
that a sincere and cordial invitation is extended to you, on behalf
of Phoenix, by the undersigned city officials.

Frank A. Jefferson

Mayor

A.F. Drune

Commissioner

Luke W. Henderson

Commissioner

Chas. E. Morton

Commissioner

Henry Rieger

City Manager

A.Z. Brehm

Commissioner

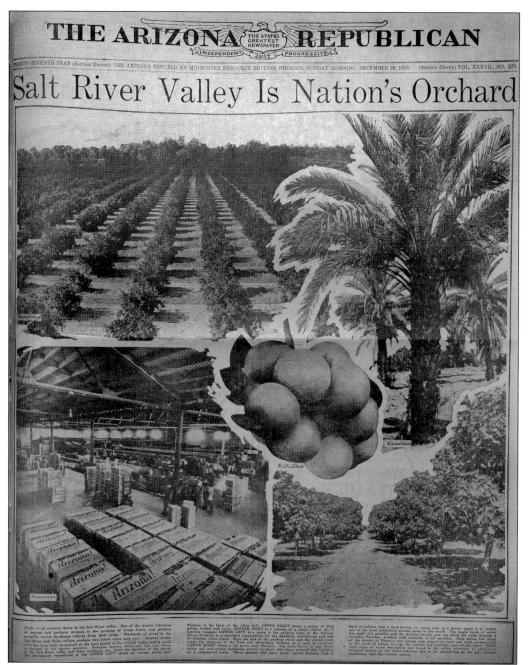

THE ARIZONA REPUBLICAN

THE STATE'S GREATEST NEWSPAPER
INDEPENDENT · JUST · PROGRESSIVE

THIRTY-SEVENTH YEAR (Section Eleven) THE ARIZONA REPUBLICAN MIDWINTER RESOURCE EDITION, PHOENIX, SUNDAY MORNING, DECEMBER 26, 1926 (Section Eleven) VOL. XXXVII, NO. 220.

Salt River Valley Is Nation's Orchard

The Sonoran Desert does not have sand dunes. Rather, it has vast open spaces, rugged peaks, and saguaro cacti. Uncommon for a desert, it has two rainy seasons: winter and summer. The winter rains are most often gentle, while the summer monsoons can be violent. Nevertheless, the Hohokam understood that through a complex system of canals diverted from the Salt River, the water would enable them to grow crops and survive despite the scorching summer heat. The early Phoenicians soon discovered the same thing. Water from the Roosevelt Dam enabled the farmers to focus on crops such as oranges, alfalfa, and cotton. Visitors were amazed, and wondered how this could be possible in a desert. (Courtesy of the *Arizona Republic*.)

Tourism was, and still is, a major industry in Arizona. One means of bringing visitors quickly and efficiently to Arizona in the late 1920s was the railroad. When the Southern Pacific line finally came to Phoenix in December 1926, the community soon recognized that there would be positive changes both commercially and personally (right). The Santa Fe Railroad touted the great state of Arizona (below) and at least one writer claimed that Arizona was "just about Paradise." Three years later, in 1929, Sky Harbor Airport opened, making it even easier for tourists to flock to this winter playland. (Right, courtesy of the *Arizona Republic*; below, courtesy of the McClintock Collection, Phoenix Public Library.)

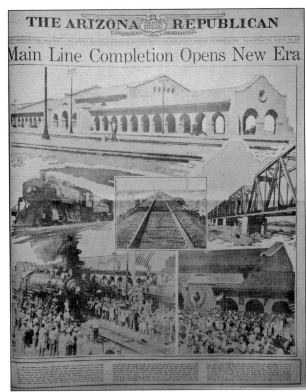

THE ARIZONA REPUBLICAN

Main Line Completion Opens New Era

great state Arizona great state Arizona

Santa Fe

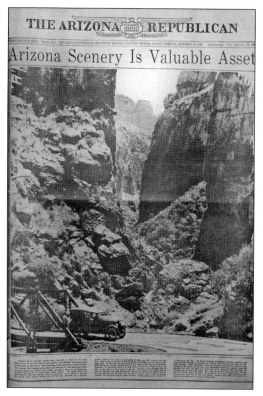

Arizona Scenery Is Valuable Asset

Majestic photographs of the grand peaks, picturesque rocks, and canyons were inviting, especially in the winter, to those who lived where snow was common (left). Not much more needed to be said about Arizona scenery. It was easy to see how Arizona could lure people with its beauty, even if the newspaper photographs were in black and white. In the mid-1920s, Arizona mines produced copper and silver (below). The communities nearby were often tucked high in the mountains. Today some of Arizona mining communities are still favorite spots for tourists. (Both, Courtesy of the *Arizona Republic*.)

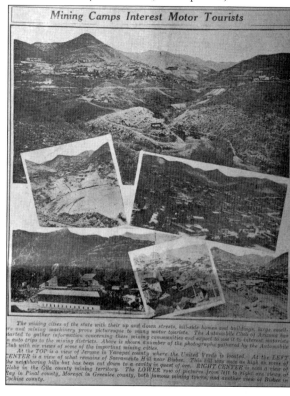

Mining Camps Interest Motor Tourists

The Castle Hot Springs (below), while not directly on the railroad route, was nearby. The resort, which would not accept people who came to Arizona to recover from ill health, would send cars to the nearest train stop to pick up resort guests. Once there, guests could enjoy the clean air and soothing waters of the hot springs, ride horses, and relax. Situated northwest of Phoenix, one of Castle Hot Springs' counterparts was the San Marcos, located in Chandler, which is southeast of Phoenix (right). The San Marcos provided opportunities for golf, tennis, hunting, fishing, and hiking, which guests were sure to enjoy because of the mild winter temperatures and the grandeur of the Sonoran Desert. (Above, courtesy of the McClintock Collection, Phoenix Public Library; below, courtesy of the *Arizona Republic*.)

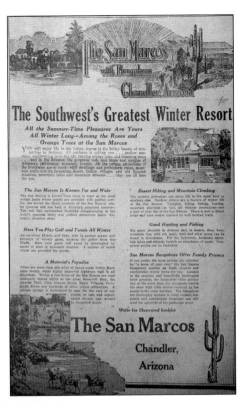

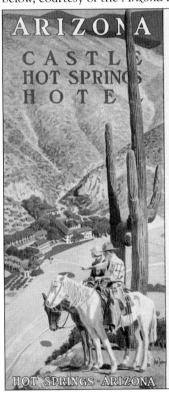

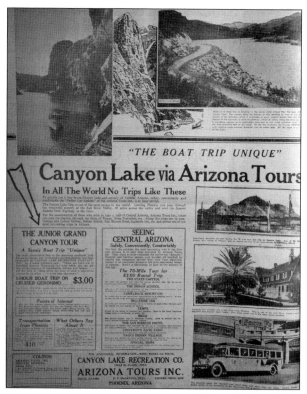

Most visitors to Arizona were awed by its diverse landscape. The highest point of the San Francisco Peaks just north of Flagstaff towered over 12,000 feet. To the east of Phoenix were the Superstition Mountains, famous for being the purported location of the Lost Dutchman Gold Mine. Tour companies offered trips to the Grand Canyon or up the Apache Trail for a view of the Roosevelt Dam (below). Sightseers discovering the lake behind that dam or Canyon Lake behind Mormon Flat Dam were sure to be impressed (left). By 1930, two more dams were completed on the Salt River, providing plenty of recreational sites for tourists and residents. The tour buses that enhanced the views with their convertible tops were merely longer versions of today's jeep tour vehicles. (Both, courtesy of the *Arizona Republic*.)

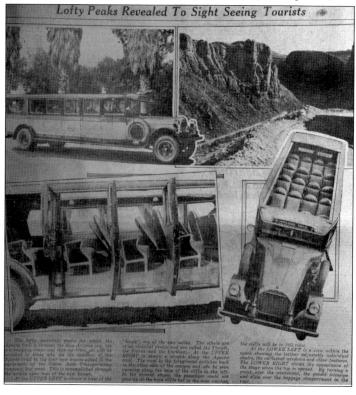

The Phoenix Arizona Club began in 1919. A local nonprofit composed of citizens and businessmen, its primary focus was to promote Phoenix as a tourist destination. To create more interest in the development of the area, they ran advertisements such as this (right). The language romanticized the area for tourists and glorified the opportunities for business and farmers. Much like a chamber of commerce, the organization published booklets (below) that contained actual black-and-white photographs demonstrating visitors enjoying the mild winter climes. Local residents could easily obtain copies to send to friends and relatives back home. It was difficult to dispute this booklet's theme: "Phoenix. Where Winter Never Comes." The internationally known *Arizona Highways* magazine, started in 1925, brought many visitors to the area. (Right, courtesy of the *Arizona Republic*; below, courtesy of the McClintock Collection, Phoenix Public Library.)

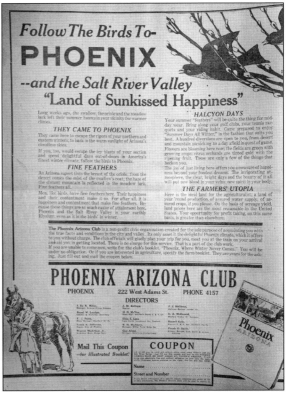

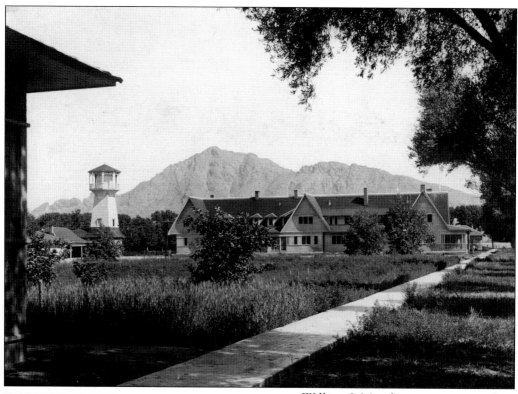

Ingleside Inn Great Pleasure Resort And Outdoor Sport Mecca

INGLESIDE INN, nestled at the foot of Camelback mountain on the very edge of the old and the new west, is probably one of the most unique pleasure-seekers' resorts in the Southwest, if not the entire United States.

It is a modern ranch hotel with bungalows that offer its patrons such service as is expected at the most exclusive resorts amid surroundings typically western and in a setting sparklingly beautiful.

Ingleside Inn is situated 12 miles northeast of Phoenix. Set in its own gem, a modern valley ranch, it is bordered by the vast desert wastes that stretch for miles to the north, sloping gradually to the mountains that mark the end of vision.

The Inn was founded as a ranch property and developed as such into one of the finest tracts in the great Salt River Valley, richest of all irrigation projects. Then its owner conceived the idea of transforming the beautiful tract into a winter resort, that the people of other sections of the nation might enjoy it.

From this humble beginning, the present resort has been constructed, set in the center of great orange, grapefruit and olive groves. It depicts the West at its best. The air is light and invigorating, desert-cleansed, the winter days warm and bright offering maximum outdoor life.

Broad reaches of grass spread out in all directions from the main structure and the bungalows. Landscaping has been effected with an artistic touch and blooming flowers add to the beauty of the picture.

Ingleside Inn is genuinely a pleasure resort in every sense of the word, a resort for rest and comfort, for relaxation and the proper exercises so necessary to good health. It is not a health resort.

It features life in the open and because of climatic conditions, it is enabled to carry out a winter-long program of outdoor sports and recreations. Practically every day is an outdoor day through the Ingleside season, from late October to early May. Desert and mountain picnics comprise a part of the regular routine, supplementing the daily riding or walking parties, golf or tennis games.

The Inn ranch comprises several hundred acres and the hotel grounds are beautifully parked and surrounded by 12,000 fruit and shade trees, 100 acres being in 30-year-old orange, grapefruit and olive groves.

It was here, in fact, that the citrus and olive industries of the valley had their beginning, for the father of the present owner set out the first fruit trees in the community on this ranch.

The orchards are open to Ingleside patrons, too, a departure from the customary plan of simply having "picture groves" for the patrons to look at. Any patron is free at any time to enter any of the orchards and pick whatever fruit he or she desires.

The hotel and bungalows are fur-

William J. Murphy, one promoter of the construction of a canal system in Phoenix, built a private hotel, the Ingleside Club (above), as a place for investors to stay. Constructed in 1910 in the desert near Scottsdale, Arizona, it had a clubhouse, golf course, and tennis court. The first true resort in the Salt River Valley, the club became known as the Ingleside Inn in the early 1920s. Midwesterners who stayed there enjoyed elegant western hospitality. Newspaper accounts regarding the resort's amenities (left) used such terms as pleasure, modern, and mecca to describe the luxury of the setting. Wealthy winter visitors increasingly bought homes in developments surrounding resorts where they had previously stayed. (Above, courtesy of McClintock Collection, Phoenix Public Library; left, courtesy of the *Arizona Republic*.)

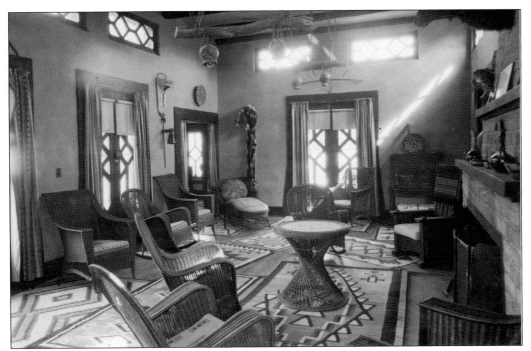

The Wigwam Resort opened in 1929 near Litchfield Park to the west of Phoenix. The site had originally accommodated Goodyear Tire and Rubber Company executives who came to the valley to oversee the company's cotton fields. The executives felt that the site would be ideal for winter vacations, so the company opened a 24-room resort. A portion of the original building remains at the current Wigwam Golf Resort and Spa. (Courtesy of the McClintock Collection, Phoenix Public Library.)

The design of the drawings for the Roosevelt Hotel changed slightly before construction and it opened as the Hotel Westward Ho. It is located on the northwest corner of Central Avenue and Fillmore Streets just a few blocks north of the San Carlos Hotel, another early Phoenix hotel. (Courtesy of the *Arizona Republic*.)

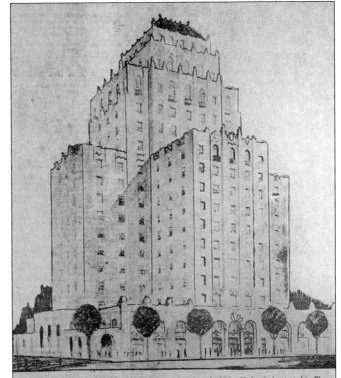

Drawing of new $1,200,000 Roosevelt Hotel, construction of which will shortly be started in Phoenix. The new structure will be erected on the E. J. Bennitt property, northwest corner of Central avenue and Fillmore street and will rise for 16 stories in the form of a Maltese cross. The Los Angeles firm of Sutherlin, Barry and company, Inc., is the operating company and the contract has been let to Threwitt, Shields and company of the same city. All stocks and bonds for the new structure have been underwritten. Test drillings for foundations have already been made and actual construction will begin not later than March 1, according to John E. Sutherlin, president of the operating company.

City business advertisements such as the one above assured that tourists felt welcome. Even those who had problems with their cars knew that they would find a competent place with friendly service. It would never do for such tourists to tell their friends that Phoenix lacked hospitality. Phoenix also had cultural offerings for tourists (below). Nestled on the north side of Camelback Mountain, Echo Canyon Bowl was an ideal outdoor concert area with its picturesque sandstone walls. Despite the dream of the Echo Canyon Bowl Association to pattern the area after the Hollywood Bowl in California, the outdoor amphitheatre did not come to fruition. (Both, courtesy of the *Arizona Republic*.)

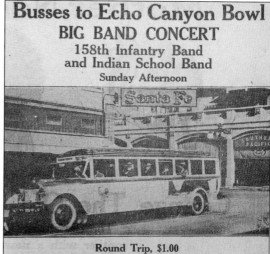

g Understone During Brief S

Aged Couple Living On Tempe
Highway Have Notable Careers

By W. H. Zoo<

A very interesting old couple are living on the main highway between Tempe and Phoenix, Ariz., on the ranch known as the "Warner Heights." The attention of the writer was first drawn to them at the Old Folks party held at Mesa in April, where Mr. Warner was crowned "King" as the oldest man present, having attained the ripe old age of 91. His wife, Lizzie Warner, is 84.

With his recent acquired title of king, King Ferdinand Warner was born in Germany, and when a young man came to America, and was in the south at the outbreak of the Civil war. His family had large holdings of land along the Mississippi river, producing sugar cane. They owned many slaves. During the war he was raised to the commission of colonel under General Forest in the Confederate army. He had charge of the heavy artillery, Company "A." This position he held for three years until Lee surrendered. He was in Georgia at the time the general surrendered.

Much of the land formerly held by his family was given to the negroes at the close of the war. The field of his service embraced Tennessee and Georgia. He was wounded 57 times and was in an equal number of battles. His last battle was at Chickamauga. After the war was over Colonel Warner says he returned home but found things quite different. There was little food to be had to eat, and most of the food was canned goods. Later he came to Arizona and was at one time in business in Tempe. Mr. Warner was married to Mrs. Warner 19 years ago. They have outlived all their children and also all their brothers and sisters.

Mrs. Lizzie Warner was born in Switzerland in the town of Basel. When a girl she came to America in a sailing vessel. It required six weeks to make the trip. For many years she lived in Columbus, Ohio, and taught school. During the Civil war she was engaged in making bullets for use in the Union army.

When a young girl she developed a talent for painting. Although she never took a lesson she has painted a large number of very fine paintings. One of the noted artists from the east once called on Mrs. Warner to look over her production of paintings. His comment was that not one in 1,000 could paint with as much accuracy without having taken any lessons, as Mrs. Warner. During her lifetime she had produced a large number of paintings and had a large number of them in their home which was located near the house they now occupy. One day while they were in Phoenix the home caught fire and burned up everything, including a valuable two-volume library. They then moved to the house which they now occupy. In this home one will...

Valley Pioneers

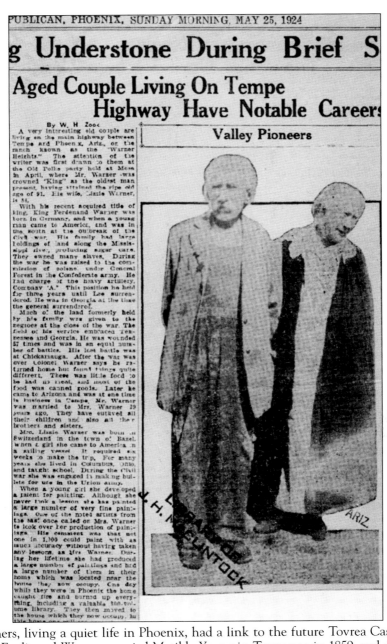

The Warners, living a quiet life in Phoenix, had a link to the future Tovrea Castle. Born in Germany, Ferdinand Warner married Matilda Young in Tennessee in 1859, and she bore him several children. It is unclear why, but he moved to Arizona alone, first appearing in the Phoenix city directory in 1892. Ferdinand, Fred, or F. Louis as he often was called, eventually opened a grocery store on Washington Avenue near Center Street at the age of 58. Lizzie Hadley, born in Switzerland, came to Phoenix with her husband, William S. Hadley, after having lived in Texas for a number of years. In those early days in Phoenix, Lizzie Hadley taught art. She divorced William in 1897 and she married Ferdinand. They lived in a house atop a granite knoll on 160 acres that F. Louis successfully homesteaded in September 1907. Lizzie's only son, William Hadley, died in 1906, leaving her his 160-acre homestead, which was adjacent to the one she and Ferdinand had. This is the only known photograph of the Warners. (Courtesy of the *Arizona Republic*.)

Mrs. Lizzie Warner Offers Acre Of Land To Kindest Boy Scout

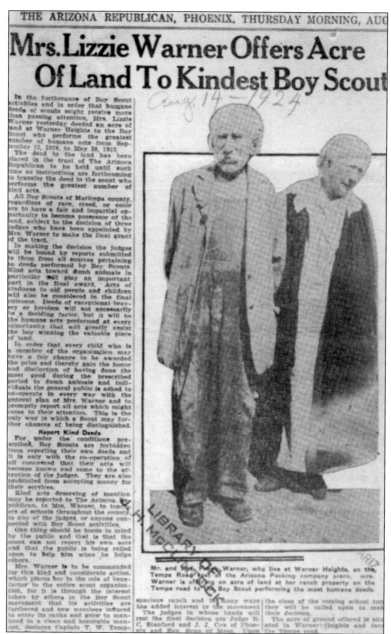

In the furtherance of Boy Scout activities and in order that humane deeds of scouts might receive more than passing attention, Mrs. Lizzie Warner yesterday deeded an acre of land at Warner Heights to the Boy Scout who performs the greatest number of humane acts from September 12, 1924, to May 20, 1925.

The deed to the land has been placed in the trust of The Arizona Republican to be held until such time as instructions are forthcoming to transfer the deed to the scout who performs the greatest number of kind acts.

All Boy Scouts of Maricopa county, regardless of race, creed, or color are to have a fair and impartial opportunity to become possessor of the land, subject to the decision of three judges who have been appointed by Mrs. Warner to make the final grant of the tract.

In making the decision the judges will be bound by reports submitted to them from all sources pertaining to deeds performed by Boy Scouts. Kind acts toward dumb animals in particular will play an important part in the final award. Acts of kindness to old people and children will also be considered in the final outcome. Deeds of exceptional bravery or heroism will not necessarily be a deciding factor, but it will be the humane acts performed at every opportunity that will greatly assist the boy winning the valuable piece of land.

In order that every child who is a member of the organization may have a fair chance to be awarded the prize and thereby gain the honor and distinction of having done the most good during the prescribed period to dumb animals and individuals the general public is asked to cooperate in every way with the general plan of Mrs. Warner and to promptly report all acts which might come to their attention. This is the only way in which a Scout may further chances of being distinguished.

Report Kind Deeds

For, under the conditions prescribed, Boy Scouts are forbidden from reporting their own deeds and it is only with the co-operation of all concerned that their acts will become known and come to the attention of the judges. They are also prohibited from accepting money for their services.

Kind acts deserving of mention may be reported to The Arizona Republican, to Mrs. Warner, to teachers of schools throughout the county, to any of the judges, or anyone connected with Boy Scout activities.

One thing should be borne in mind by the public and that is that the scout can not report his own acts and that the public is being relied upon to help him when he helps others.

Mrs. Warner is to be commended for this kind and considerate action, which places her in the role of benefactor to the entire scout organization, for it is through the interest taken by others in the Boy Scout movement that its activities are furthered and new members induced to enter its ranks and grow to manhood in a clean and honorable manner, declares Captain T. W. Temp-

Mr. and Mrs. ___ Warner, who live at Warner Heights, on the Tempe Road east of the Arizona Packing company plant, are Warner is offering an acre of land at her ranch property on the Tempe road to ___ Boy Scout performing the most humane deeds.

spacious ranch and in many ways has added interest to the movement. The judges in whose hands will rest the final decision are Judge B. C. Stanford and J. J. Cox of Phoenix and Rev. ___ of Mesa. Upon the close of the coming school term they will be called upon to make their decision.

The acre of ground offered is situated in Warner Heights and faces the Tempe road.

Prior to arriving in Phoenix, Lizzie Warner was active in Eastern Star on both the state (Texas) and national levels. After her marriage to Ferdinand Warner, she was active in such organizations as the United Daughters of the Confederacy, of which she was an honorary member despite her northern roots. Lizzie Warner had a philanthropic nature too. In August 1924, she offered 1 acre on the Northwest corner of her late son's property facing Tempe Road to a local Boy Scout who performed the most "humane acts" between September 1924 and May 1925. She arranged for a panel of three judges to review the submissions and had the *Arizona Republican*, a local newspaper, hold the property in trust. Unfortunately, she died April 6, 1925. While the county records show Lizzie's husband transferred the property to the Roosevelt District Council of the Boy Scouts of America in early 1926, the actual winner remains a mystery. (Courtesy of the *Arizona Republic*.)

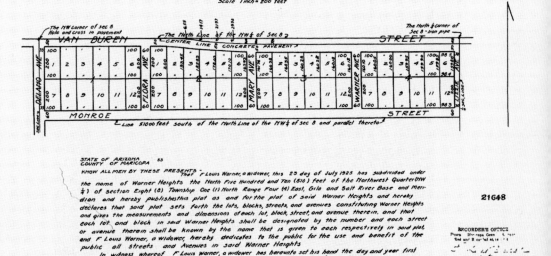

WARNER HEIGHTS

A SUBDIVISION OF THE NORTH 510 FEET OF
THE NORTHWEST QUARTER OF SECTION 8
T1N R 4E, G & S R B & M
MARICOPA COUNTY ARIZONA
Holmquist & Becker Engineers
Job No 1856 Map No C 2359
Scale 1 inch = 200 feet

Following the death of Lizzie Warner in April 1925, Ferdinand's daughter Lillie Warner Smith, a widow, moved to Phoenix to care for her elderly father. With her assistance, Ferdinand began the process of subdividing the northern portion of acreage along Van Buren Street and selling of his other property. The Phoenix economy then, like today, was driven by land speculation. It was only natural to believe that the property closest to Van Buren Street would quickly sell, as that road was the main connection between Tempe and Phoenix. This subdivision map of Warner Estates shows four blocks with 12 lots each. The street names probably have a family connection, as there is a Mary Warner buried in the Warner plot in Tempe Double Butte Cemetery. After Ferdinand's death, Lillie W. Smith gradually sold the blocks of Warner Estates and other portions of the unsubdivided property of the original two homesteaded tracts. (Courtesy of City of Phoenix.)

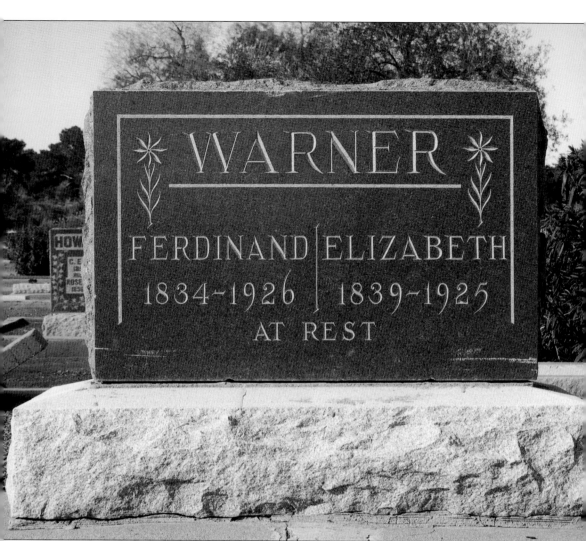

A plain headstone marks the final resting place for Lizzie and Ferdinand Warner. Situated in lots five and six of section F in the City of Tempe Double Butte Cemetery, no visitor would ever discover the connection these two quiet people had to Tovrea Castle. Nor would they learn that Ferdinand had served under Captain Sterling's command in a Tennessee heavy artillery unit in Georgia for the Confederate States of America Army during the Civil War. Lizzie had helped to make bullets for Union soldiers in Ohio. Meeting and marrying in Arizona, these two people homesteaded 160 acres between Phoenix and Tempe. The granite knoll where they built their home became the future site of Tovrea Castle. (Photograph by Donna Reiner.)

Two

BUILDING THE CASTLE

Alessio Carraro, an Italian immigrant, came to Phoenix in 1928, having sold his San Francisco sheet metal business. As many who came to Arizona before and after him, Carraro came with a dream. His was to create a resort with a castle as the centerpiece. Carraro purchased 277 acres that stretched from Van Buren to the riverbed and included the Warner property promontory. The area became known as Carraro Heights.

Using a crew of 18 men, Carraro and his son Leo began the task of building his castle in 1928. Carraro completed it in December 1930, topping the building with a cupola. That Christmas he outlined the building with lights, creating a magical setting in the desert.

A Russian gardener, M. Moktachev or "Mokta," offered his services to Carraro to create a cactus garden to enhance the grounds. Since cacti are more susceptible to injury during transport in the cooler months, Mokta worked diligently on the garden project in the summers of 1928 and 1929, searching throughout Arizona, parts of Mexico, Colorado, and California for a wide assortment of cacti. Nearly 300 cacti and other succulents were arranged with metal labels (Latin and popular names) in a terraced garden on the north and west sides of the castle with white painted river rock outlining the paths and various areas of the garden. A watering system developed from the site's 140-foot well filtered through the granite hill to provide a more natural watering for the plants.

Shortly after Carraro finished the castle, and before he had time to develop the rest of his property, E. A. Tovrea purchased the adjoining land to the south and west, where he built sheep and cattle pens for his meatpacking plant. Carraro had wanted that land to expand his resort project.

When money became tight in the early days of the Depression, Carraro began to subdivide his property. The horrific odor from the stockyards and the meatpacking plant, combined with his dwindling funds, convinced him to sell the remaining land, which included the castle. The Tovreas, owners of the stockyards, purchased it.

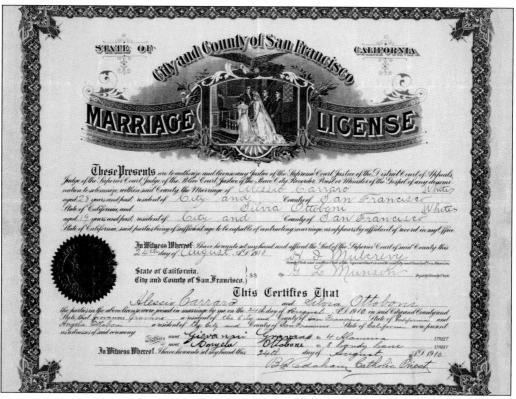

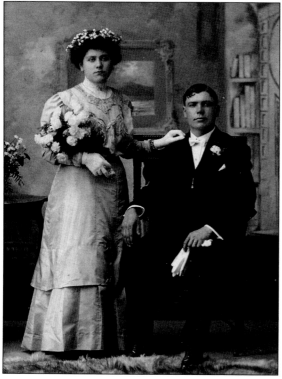

Alessio Carraro, 28, and Silvia Ottoboni, 19, took out a marriage license in San Francisco on August 24, 1910. Silvia had arrived in New York City (Ellis Island) with her parents and five siblings in October 1909. They settled in San Francisco because her father's brother lived there. Carraro, the son of a cobbler, had come to San Francisco in 1905 from Italy. Silvia's older sister Angela was a witness for the wedding. (Courtesy of Marie Cunningham.)

Silvia (left) and Alessio posed for this formal wedding picture. The Carraros lived in Sonoma, California, for a period of time, and both their children were born there. By 1918, they were back in San Francisco, where Carraro worked as a mechanic for S. Mariani and Sons. Shortly thereafter, he opened the New Mission Sheet Metal Works, his first highly successful business venture. (Courtesy of Marie Cunningham.)

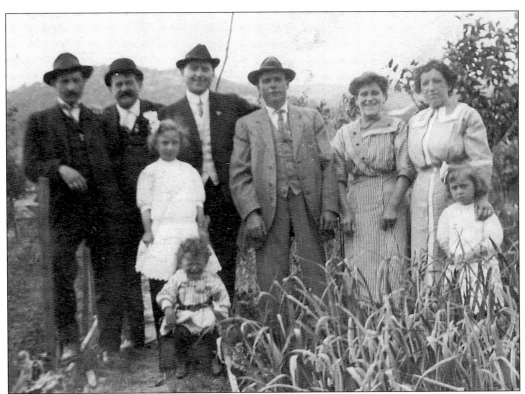

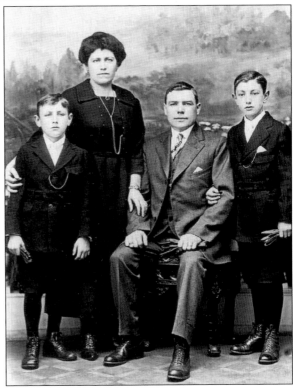

Above is an undated photograph of Alessio, fourth man from left, and Silvia, second woman from right. The woman standing next to Silvia may be her sister Angela. At right, in a formal family portrait taken in San Francisco around 1919, from left to right are Leo (Olivo), Silvia, Alessio, and Louis. By this time, Alessio's sheet metal business on Mission Street had begun. Carraro met Ben Pasqualetti from Phoenix when Ben came to San Francisco to visit his daughter, who happened to rent an apartment from Carraro. Over the years, Pasqualetti told Carraro about various land development possibilities in Phoenix. This eventually led Carraro to enter the Phoenix real estate market following the sale of his sheet metal business in 1925 and at least one lucrative real estate development project in California. Carraro also invested in the stock market. (Both, courtesy of Marie Cunningham.)

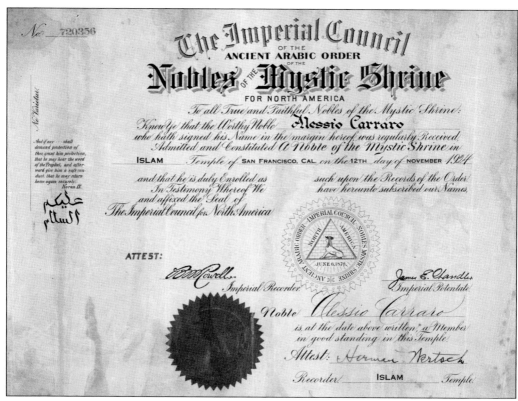

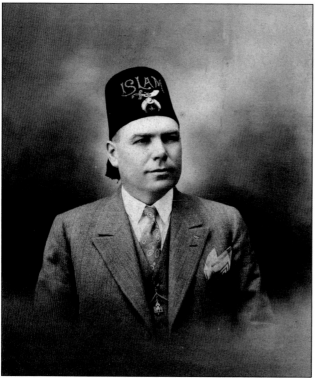

The Shriners, properly called the Ancient Arabic Order of the Nobles of the Mystic Shrine, is a men's social and charitable organization of the Freemasons. While the founding group of men adopted a Middle Eastern theme, the Shriners organization is not religious and has no connection to Islam. The Shriners met in buildings they called temples and each individual group had a distinct name. San Francisco's Islam Temple was founded in 1883 and is the oldest in California. Carraro joined the Islam Temple November 12, 1924 (above). Showing Carraro dressed in the traditional red fez with the name of his shrine, the undated picture on the left probably was taken in the mid-1920s. Carraro later joined the El Zaribah Shrine in Phoenix. (Both, courtesy of Marie Cunningham.)

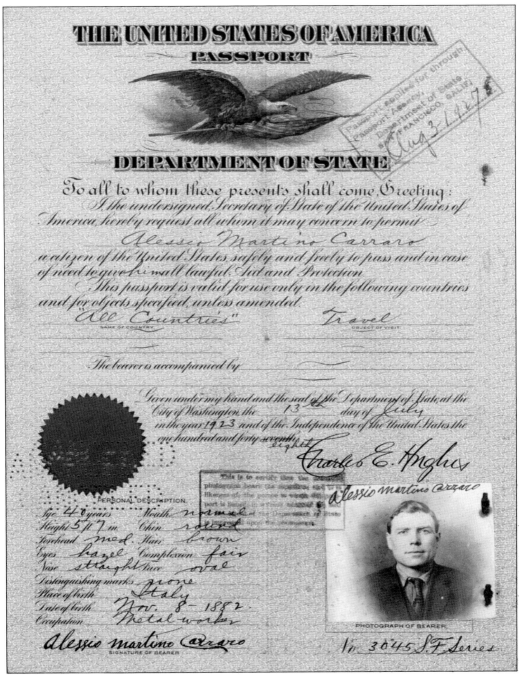

In 1923, Alessio Martino Carraro took a trip to Italy, leaving his wife and two boys in San Francisco. His passport, dated July 1923, provides an excellent physical description of Carraro. No records were found as to what ship and when Carraro sailed to Italy. However, shipping records indicate that Carraro sailed aboard the S.S. *Conte Verde* to New York City from Genoa, Italy on October 3, 1923. These shipping records also indicate that Carraro became a naturalized citizen of the United States on July 10, 1923, three days before he received his first American passport. (Courtesy of Marie Cunningham.)

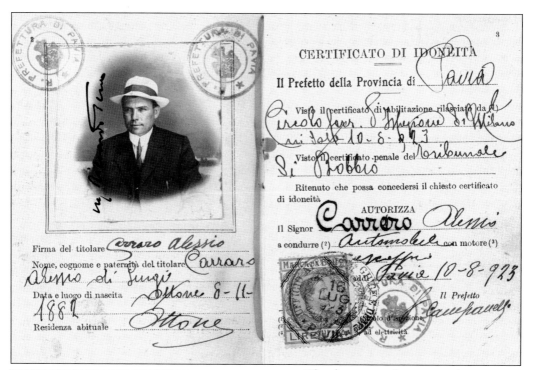

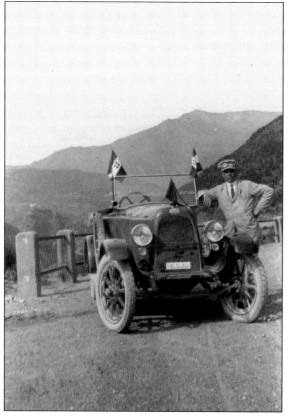

The document above is similar to an international driving permit. It reveals that Carraro was from the small town of Ottone, located in the province of Piacenza northeast of Genoa. The convertible car below, possibly a 1919 Fiat 505, is parked alongside a road in the mountains of northern Italy. Carraro is dressed in typical touring clothes, including hat and driving goggles, as he was participating in an Italian road rally according to family records. (Both, courtesy of Marie Cunningham.)

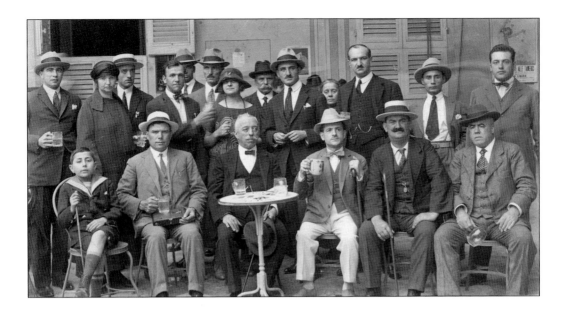

The group photograph above was taken on Carraro's 1923 trip to Italy. Carraro is seated to the right of the young boy in the front row. All the other people are unidentified. Based on the information printed on the front, this scene is in Montecatini-Tettucio, which is in the province of Pistoia in north central Italy (Tuscany). It seems that in every town Carraro stopped on this road rally, the villagers gathered for a picture and drinks (below). Carraro is standing in the front row, far left. He spent at least two days in the town of Montecatini-Torretta based on the dates of two photographs. Having left Italy some 18 years prior to this visit, it must have been a delight for Carraro to spend time in the country of his birth. (Both, courtesy of Marie Cunningham.)

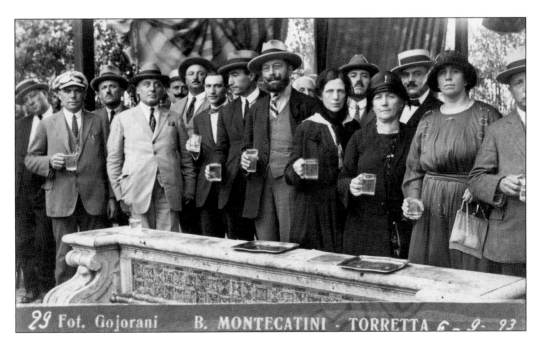

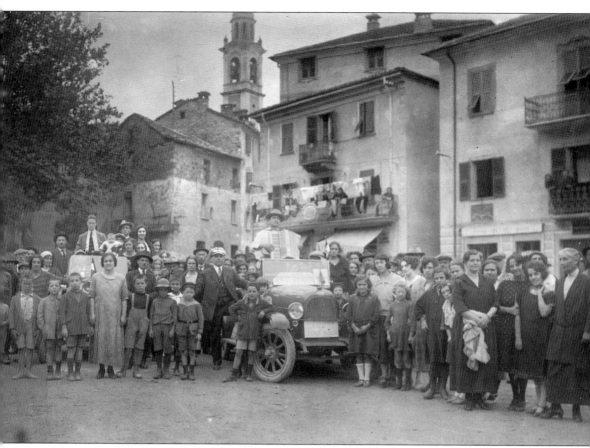

Alessio is standing to the left of the car. He is in a suit and wearing a hat with goggles on the top. The village is unidentified. It would appear from the turnout that it was something special to be included in the picture, considering all the children pictured in front. The man with the accordion in Carraro's car suggests a festive occasion. And a number of other people have crowded into his car for this group photograph. The other car in the left background may also be a participant in the road rally. The signs on Carraro's car are too faint to clearly decipher. However, the sign on the radiator does refer to Alessio as a friend. One of the small flags above the radiator cap may be an American flag. (Courtesy of Marie Cunningham.)

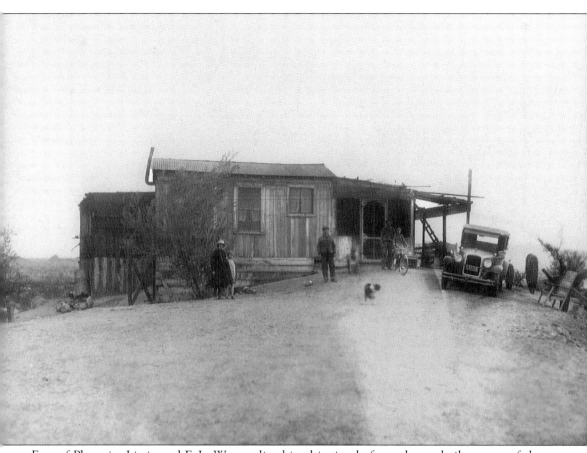

East of Phoenix, Lizzie and F. L. Warner lived in this simple frame house built on top of the central knoll on the property. Lillie Warner Smith, the daughter of F. L. Warner, lived in the house following the death of her father along with her son and granddaughter. Smith may be the woman standing on the left with the young child. According to Leo Carraro, Smith offered Alessio a drink of her well water when he came to inspect the property. Apparently that act along with the fact that the water was the best Alessio had ever tasted sealed the bargain. When the property sale was complete, Smith offered to buy the 1927 Buick Alessio and Leo had driven from San Francisco to Phoenix. According to Leo's telling of the story, Alessio agreed. (Courtesy of Marie Cunningham.)

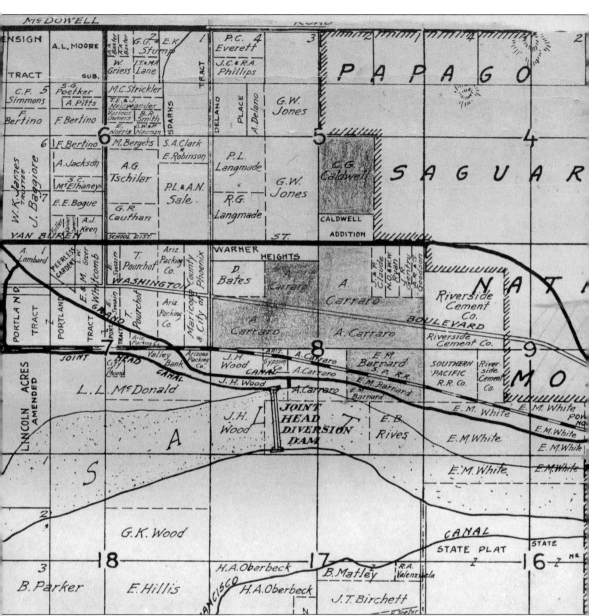

This undated map shows the 277 acres that Carraro originally purchased and indicates his neighbors. Papago Saguaro National Monument is on the right side of the map. Carraro owned property clear to the Salt River (close to bottom of the map), which made it easy to haul the river rocks that he used to line the garden walks and the slope of the knolls. Look carefully to the left of the Carraro property to find the land belonging to the Arizona Packing Company. This is the firm owned by E. A. Tovrea and the place where Tovrea began construction of his stockyard and meatpacking plant. Tovrea gradually purchased more land on the west side of the castle area. Warner Heights was the portion previously subdivided by F. L. Warner. (Courtesy of Marie Cunningham.)

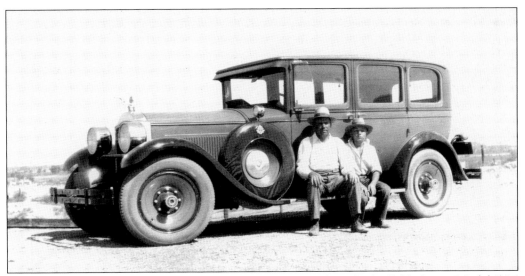

Alessio (left) and his son Leo (right) sit on the running board of a Fifth Series Model 5-26 Packard five-passenger six -cylinder sedan body style 303 (produced July 1, 1927–August 1, 1928) in this undated photograph. This model came in 12 different body styles and wheelbases. It is unclear whether Carraro owned the car or had borrowed it for some purpose. (Courtesy of Marie Cunningham.)

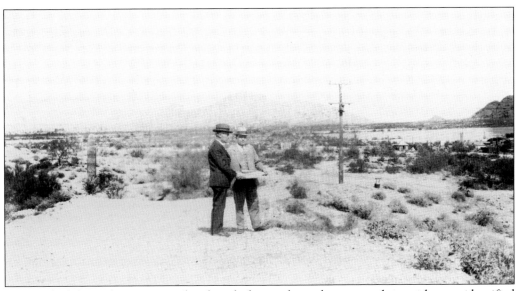

Carraro (right) may be reviewing the plans for his castle on the proposed site with an unidentified gentleman. The other man could be Henry D. Frankfurt, the local architect that Carraro initially hired to sketch a castle design. However, no formal architectural renderings resulted from Frankfurt's castle sketches. (Courtesy of Marie Cunningham.)

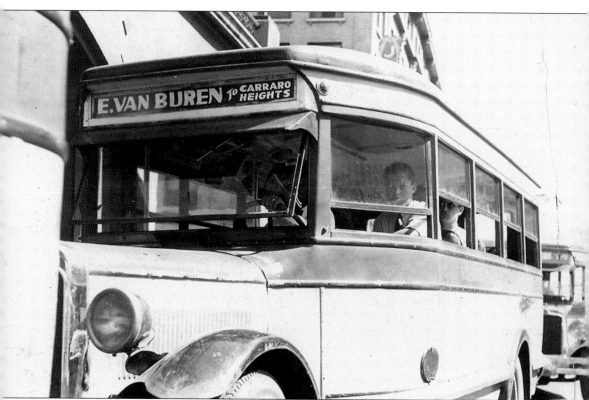

This 1929 photograph features the bus that came from the center of Phoenix and headed east on Van Buren Road ending at Carraro Heights, a little over 7 miles from the center of town—just what a budding hotel proprietor needed to make sure that guests could easily reach their accommodations. On Sundays the bus also brought visitors who wanted to see the gardens while the castle was being built, which may be where some of these passengers were going. (Courtesy of Marie Cunningham.)

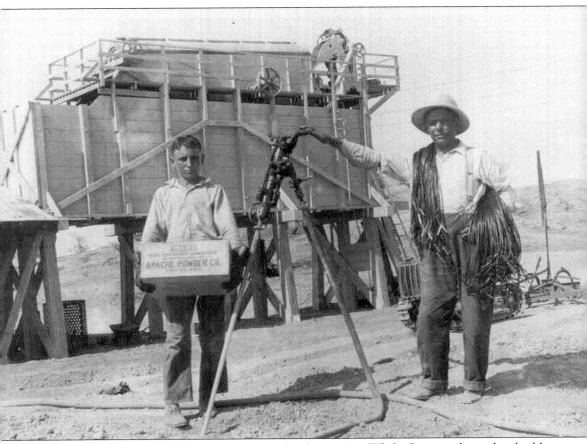

Building a castle necessitates an appreciation for the terrain. While Carraro planned to build his castle on the top of a crag, at least he did not need to worry about a moat or any other of the "standard" components associated with protection of a castle. Still, every building has challenges, and the granite that dominated the site was one of the greatest to overcome. The primary granite knoll had to be leveled. Carraro solved that problem by blasting. Leo (left) holds a box of Apache Black blasting powder. Alessio (right) has wires draped around his shoulders, which may have been used with the charges. The machine in the background was used to crush the granite, which Carraro then used to make concrete blocks. (Courtesy of Marie Cunningham.)

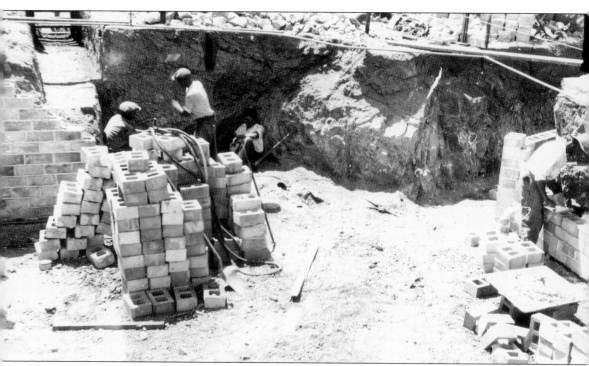

Carraro apparently followed his own architectural vision for his castle, which resulted in the elongated octagonal design. This may have been influenced by his 1923 trip to Italy. Carraro hired a man to blast a 40-foot-by-60-foot hole in the knoll to prepare the site. Three corners had deep trenches for the tunnels (northeast, northwest, and southwest) and one had a short opening (southeast). The workers in this photograph are constructing the foundation of the castle at the northwest corner of the basement. The concrete blocks are the ones that Carraro made on site using the decomposed granite he found on his property after making the flat site pads where he could build. The blocks were also used to construct the well house, gas station, and retaining walls. (Courtesy of Marie Cunningham.)

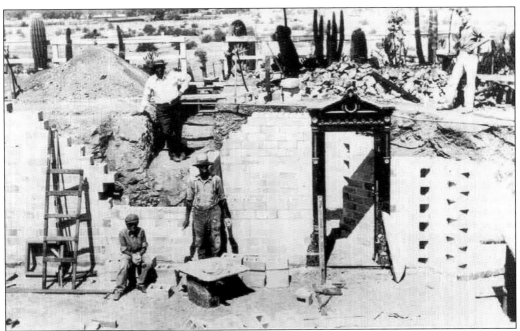

The concrete blocks form the basement wall, which would become the foundation for the castle. The vault frame would have a small room behind it, which was to be the hotel wine cellar. Although the people are unidentified, the man standing behind the two workers is in the area that became the air shaft from the basement to the outside. Note the split-wood railing and cacti already in place. (Courtesy of Marie Cunningham.)

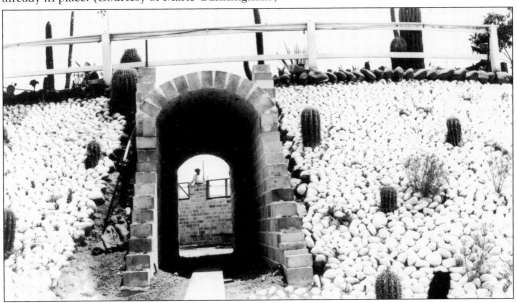

Looking from the outside through one of the tunnels provides a view to the other side of the basement. It is interesting to see that the white river rock is already in place along with some cacti and the spilt railing. Carraro's method of construction appears to be rather unusual, since the landscaping was done simultaneously with the building of the castle. (Courtesy of Marie Cunningham.)

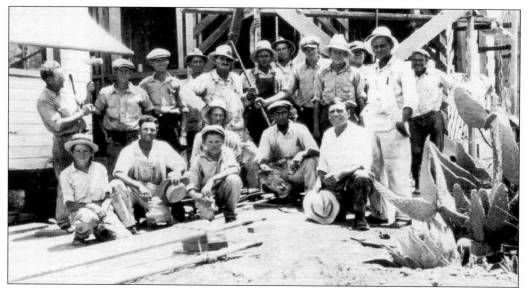

Alessio and his son Leo built the castle with the help of 18 or so men. In this group picture, Alessio is in the front row (right) holding the white hat. All others are unidentified. The white building on the left housed the kitchen to feed the workers. The first-floor framing of the castle is seen behind the group. (Courtesy of Marie Cunningham.)

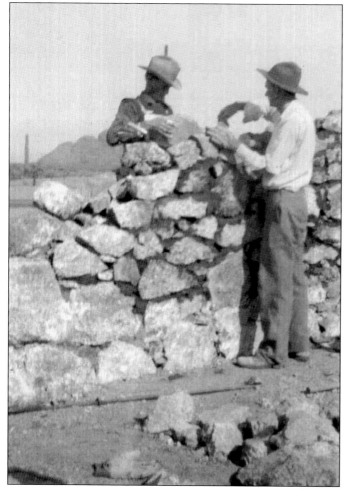

These two men are building the rock wall using granite from the site. The Papago Buttes are in the background. (Courtesy of Marie Cunningham.)

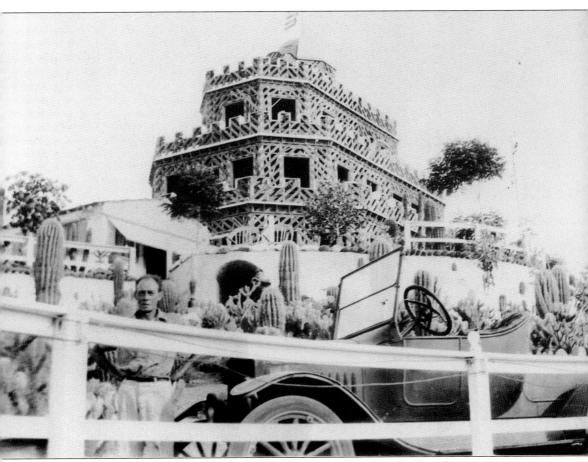

The unidentified gentleman stands next to a Model T in the cactus garden. But the most interesting aspect of this picture is the intricate framing of the building in the background. The cupola already has flags flying, much like one might see in a topping out of a high rise building today. The cactus garden is in. The split-wood railing along the driveway is complete. A basement tunnel is visible. The low white building to the left is where Leo and Alessio slept while working on the castle, and it also housed the kitchen area for the crew. (Courtesy of Marie Cunningham.)

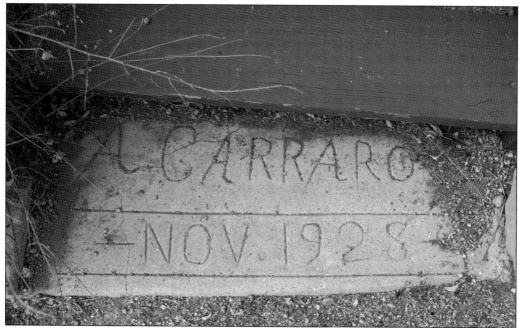

Carraro left a visible and permanent reminder that this project was his at the bottom of the wood steps that descend from the south patio of the castle. November 1928 marked the christening of the circular driveway just inches away from this marker. The driveway came from Van Buren Street and circled the cactus garden. (Photograph by Donna Reiner.)

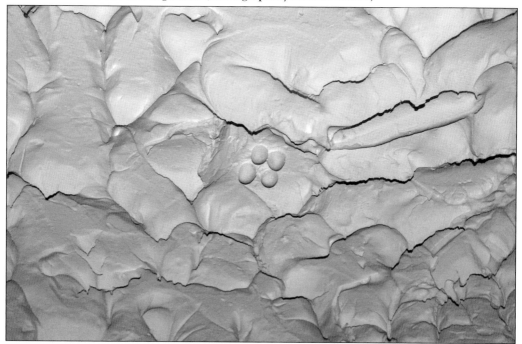

Carraro's son Leo left a more subtle permanent mark in the castle. Cleverly hidden in the plaster meringue ceiling of the basement are five "nests" of eggs. About the size of a robin's egg, these clusters of plaster eggs are fun to find. (Photograph by Donna Reiner.)

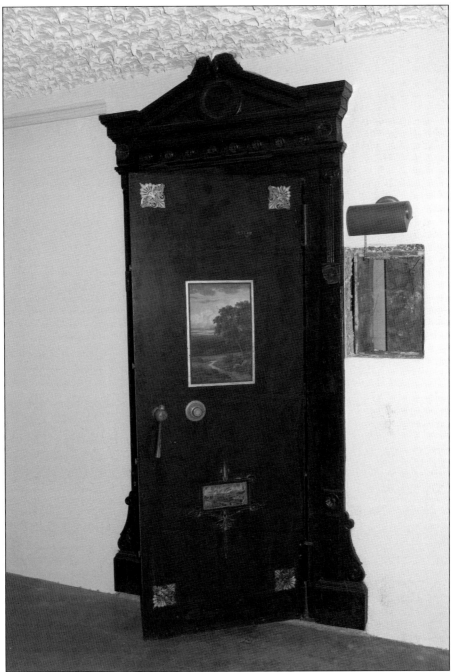

Carraro was a consummate recycler, a man ahead of his time based on today's standards. When he heard that a local bank was undergoing interior remodeling, he acquired the old vault to put in the basement of his castle, where it served as the wine cellar. Carraro also took the mahogany from the tellers' area and had it refashioned into cabinets for the kitchen. Maple flooring destined for some project that never came to fruition was also put to use in the castle. The impressive bank vault door hides the fact that Carraro wallpapered the interior of his future wine cellar with newspaper. (Photograph by Donna Reiner.)

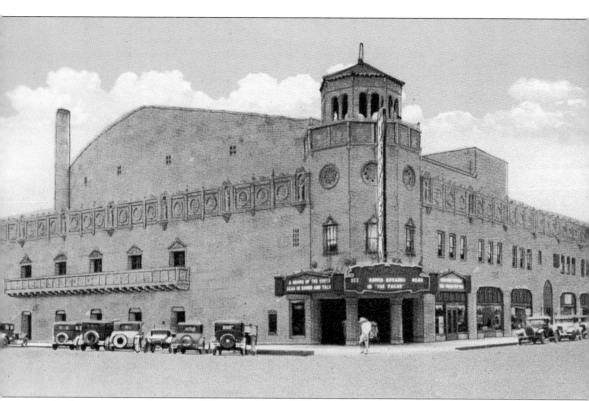

At the same time that Carraro was building his dream castle east of Phoenix, a magnificent new theater designed by the local firm of Lescher and Mahoney was going up on the southeast corner of Adams Street and Second Avenue. Construction of the Orpheum Theater, built for $750,000, began in 1927. That same year construction also began on the Luhrs Tower on Jefferson Street, the Hotel San Carlos on Central Avenue and Monroe Street, the Westward Ho Hotel on Central Avenue and Fillmore Street, and the combined city hall/county courthouse on the block between Washington and Jefferson Streets and First and Second Avenues. Extravagant even at that time, the Orpheum Theatre opened in January 1929. It marked the last major project in downtown Phoenix before the 1929 stock market crash. Italian artisans helped with construction of this Spanish medieval and baroque–style building. (Courtesy of Ron Heberle.)

This medallion in the Orpheum Theater is just one of the many details the artisans created throughout the building. The ornamentation on the proscenium arch over the stage opening has a number of medallions, two of which are identical to the one over the mantle in Tovrea Castle. These are now in gold and reddish paint, which some experts believe is not the original coloring. (Photograph by Ron Heberle.)

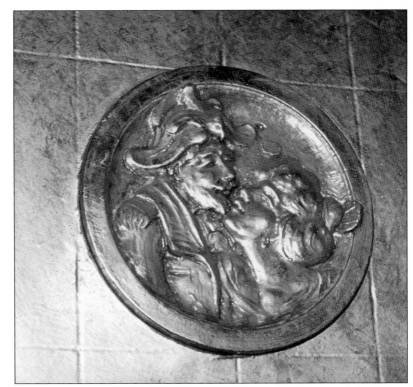

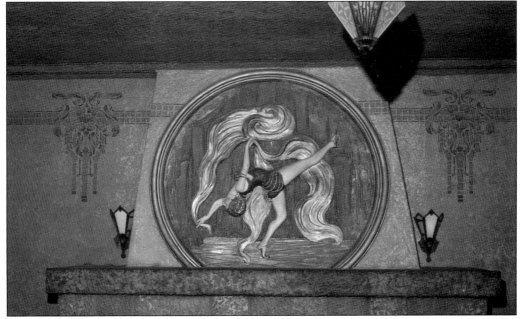

Carraro offered to let the Orpheum artisans use his machine shop to cast the plaster of Paris medallions for the theater. They in turn made one for Carraro's hotel. The flapper appears ready to come down from her perch over the nonfunctioning fireplace and terrazzo hearth dancing across the grand castle room. Not brassy looking as the Orpheum Theater medallions, this one appears softer, like a painted relief. (Photograph by Steve Weiss/Candid Landscapes.)

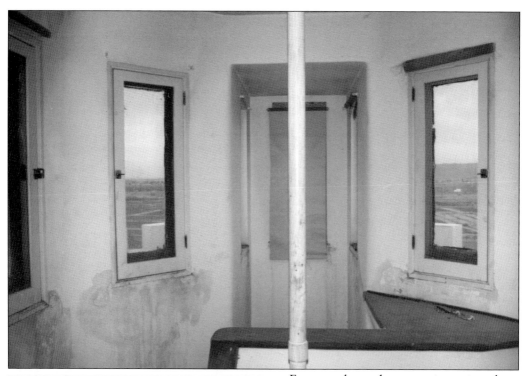

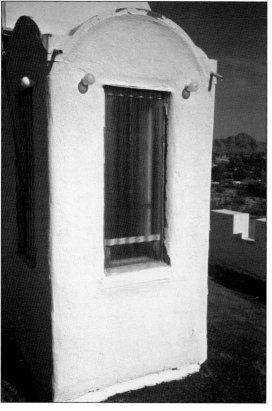

Every castle needs a crowning point where the owner and/or guests could view the commanding landscape—the castle's domain, so to speak. Tovrea Castle has a cupola with a flagpole. While narrow stairs lead to the cupola, once there a visitor must cleverly maneuver inside to a ledge in order to look out the windows (above). The views from the top, though, were worth the effort then and still are. The exterior details are simple on this portion of the building. A narrow door to the outside allows the visitor to carefully walk around, as the battlement wall is not very high (left). (Above, courtesy of Marie Cunningham; left, photograph by Steve Weiss/Candid Landscapes.)

Apparently Carraro never took pictures of the castle's interior after it was completed. The picture at right of one of the many ceiling light fixtures on the first floor dates from the 1970s. Each of these art deco fixtures on the first floor has painted stenciling surrounding it. Wall sconces and stenciling also decorate the walls of both main rooms on the first floor of the castle (below). (Above, courtesy of Marie Cunningham; below, photograph by Steve Weiss/Candid Landscapes.)

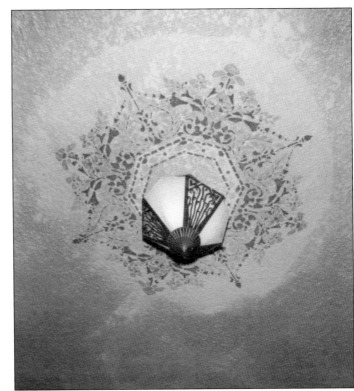

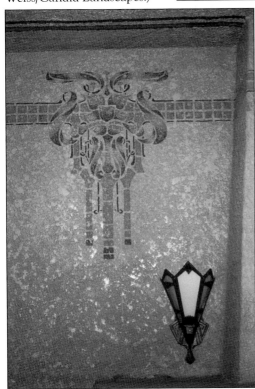

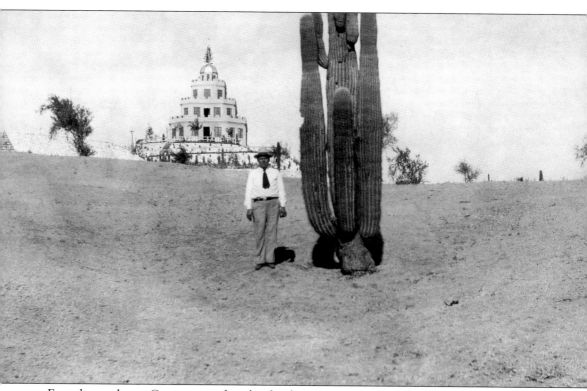

Ever the marketer, Carraro, standing by this large saguaro, outfitted the battlements and walls with decorative lights. Situated as it was, the night lights would be seen for miles in the clear desert sky. With the construction completed just before the Christmas holidays in 1930, he installed colored lights and placed a lighted Christmas tree atop the cupola. Entering the *Arizona Republican*'s Phoenix Spirit of Christmas outdoor decoration contest, Carraro won the paper's sweepstakes prize. The newspaper's announcement referred to the hotel as a castle—a label that has been used ever since. (Courtesy of Marie Cunningham.)

Alessio Carraro (right) and an unidentified gentleman stand in the cactus garden in this undated photograph. Mokta, the Russian gardener, had acquired some more mature saguaros based on this photograph. (Courtesy of Marie Cunningham.)

On a Sunday afternoon, Leo is all cleaned up and wearing what appears to be lightweight white slacks, shirt, and a pith helmet. He is standing in the cactus garden. Some of the rock steps are visible on the right side of the photograph. (Courtesy of Marie Cunningham.)

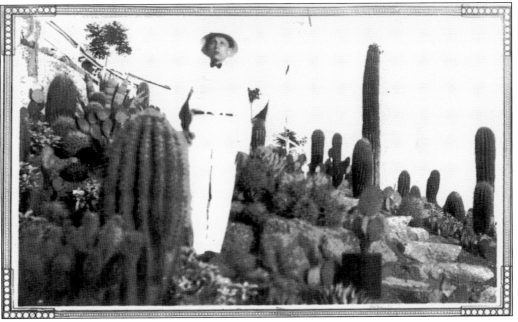

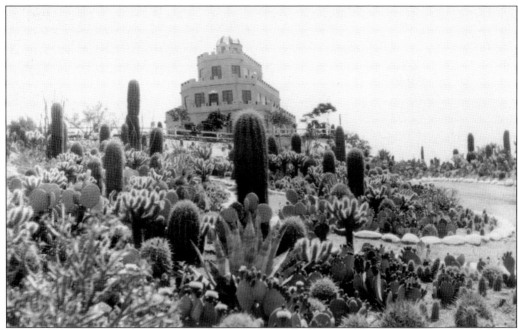

This photograph, taken around 1930, shows how dense the plantings were in the garden. Some of the plants visible here are the slender saguaro, the teddy bear cholla, prickly pear, agave, and the stick-like ocotillo. Cacti do not normally grow so close to each other, especially in poor soil conditions, as existed on this property. (Courtesy of Marie Cunningham.)

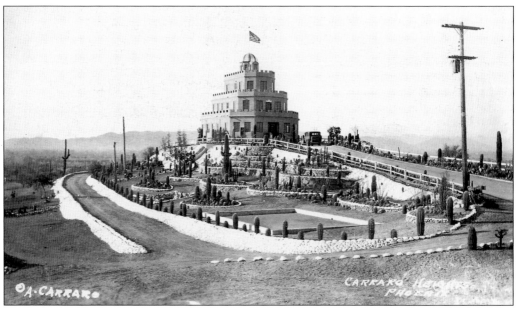

Probably taken at the same time as the picture above, this photograph is shot from the northeast side of the castle. The raised and terraced garden beds set off the various plantings. The square area toward the middle is the court for a game that was a cross between billiards and bocce. The power pole is still part of the landscape. (Courtesy of Marie Cunningham.)

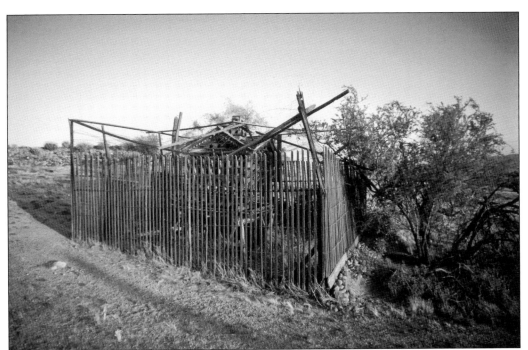

Noticing the large number of pigeons that flocked around the neighboring Tovrea Packing Company, Carraro had one of his carpenters build the elaborate dovecote seen above. It was located southwest of the cactus garden. The plump birds were easy to catch and contain in the cage (below). They provided many a main course for dinner for Carraro and his work crew. These 1983 photographs show some of the deterioration to the structure, which has since completely collapsed. (Both photographs by Gregory Davis.)

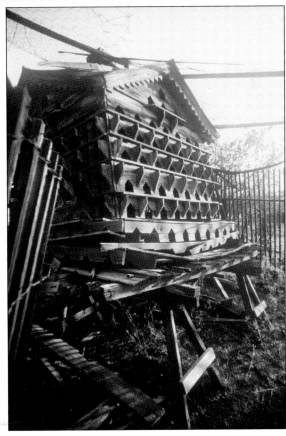

Constructed west of the castle, the structure above served as the sleeping quarters for the work crew. Measuring a little less than 750 square feet, it had a common cooking and kitchen area. After completion of the hotel, according to Leo Carraro, this building would serve as a guest house. The original Warner family well, housed in the concrete block building below, was extended from 90 feet to 140 feet. Carraro built the well house to better protect the pump compressor. Carraro had a similar concrete block building near the machine shop for an underground fuel tank. (Both photographs by Gregory Davis.)

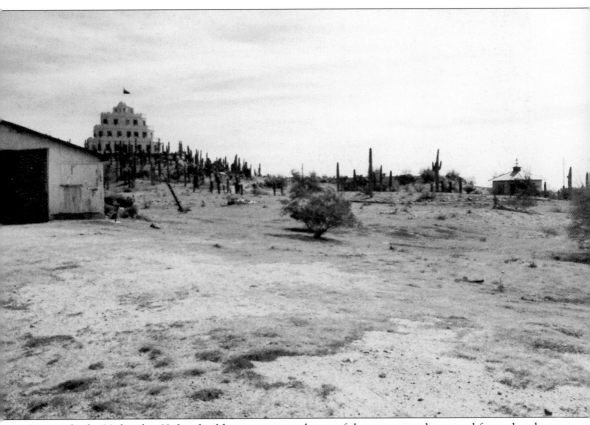

Carraro had a 30-foot-by-60-foot building constructed west of the cactus garden, wood-framed and covered with galvanized corrugated sheet metal. During construction of the castle, Carraro used this building on the left to store various pieces of equipment. There was no risk of damaging the floor of the building, as it was dirt. The building also provided some shade during the hot summer months. The small building on the right is the well house. (Courtesy of Philip E. Tovrea III.)

The castle has a commanding 360-degree view from its granite perch. To the south is prominent South Mountain, touted as the largest municipal park in the country. Its highest point is 2,690 feet. To the southeast is Tempe Butte (above), volcanic rock rising to 1,496 feet near the Salt River and the city of Tempe. The Papago Buttes to the northeast are reddish sedimentary rock (iron oxide). In 1914, they became part of the Papago Saguaro National Monument until Congress abolished the monument in 1930. To the north is Camelback Mountain (below) composed of granite and sandstone. At 2,704 feet, the shape of the sitting camel attracts photographers and hikers. Piestewa Peak at 2,608 feet and North Mountain at 2,104 feet lie to the northwest. The White Tanks, now a regional park, rise far to the west of downtown Phoenix. (Both, courtesy of McClintock Collection, Phoenix Public Library.)

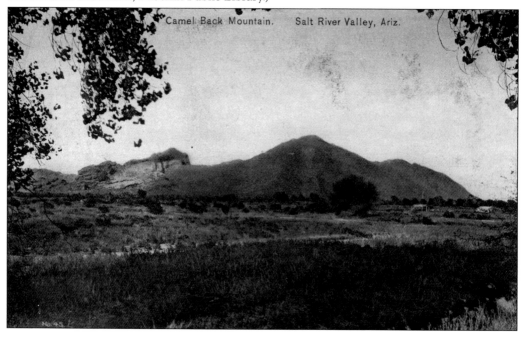

Camel Back Mountain. Salt River Valley, Ariz.

Carraro actively pursued a variety of business ventures throughout his life. After he sold the castle property, Carraro and his son Leo lived for awhile in the Huachuca Mountains in southeastern Arizona. They were either working in mines or Carraro's own mining claim during the day. Alessio played his accordion around a campfire at night. Looking for water is an art, and Carraro was quite successful at this business if having an office in San Francisco and Phoenix is any indication (above). In fact, it was reported that Carraro found 35 wells for one company alone in 1945 (below). Standing by the pipe gushing water is an unidentified man (left) and Carraro (right). (Both, courtesy of Marie Cunningham.)

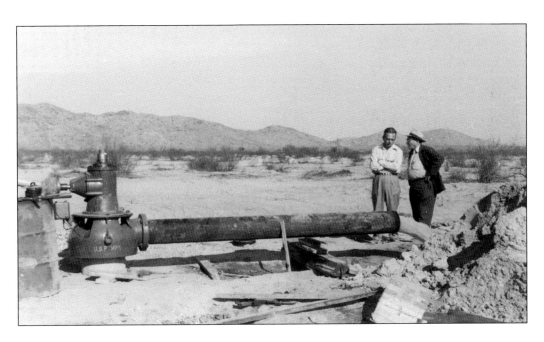

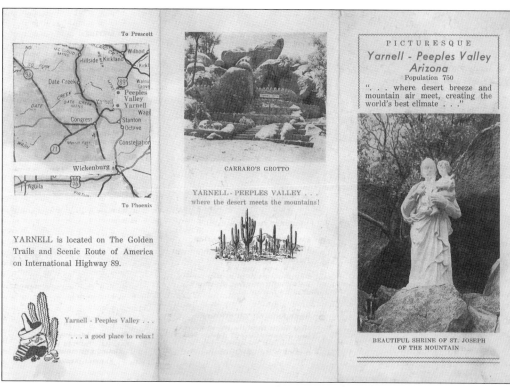

To Prescott

To Phoenix

YARNELL is located on The Golden Trails and Scenic Route of America on International Highway 89.

Yarnell - Peeples Valley . . .

. . . a good place to relax!

CARRARO'S GROTTO

YARNELL - PEEPLES VALLEY . . .
where the desert meets the mountains!

PICTURESQUE
Yarnell - Peeples Valley
Arizona
Population 750
". . . where desert breeze and mountain air meet, creating the world's best climate . . ."

BEAUTIFUL SHRINE OF ST. JOSEPH
OF THE MOUNTAIN

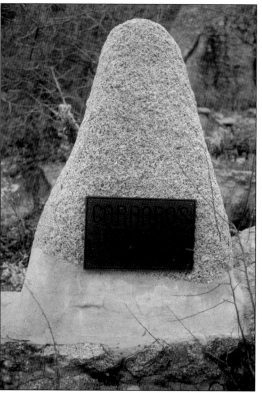

Carraro purchased some land near Yarnell, Arizona, approximately 80 miles northwest of Phoenix. A rugged area full of huge boulders, Yarnell is just off US Route 89 northeast of Wickenburg (above). There Carraro, his imaginative powers once again set free, saw the shapes of animals in the rocks. He painted signs pointing them out and sometimes added details to strengthen the image he saw. He worked on the project from 1957 until his death in 1964, building a small house amongst the granite boulders. The Carraro Grotto became a tourist attraction as visitors wandered through the area, fascinated by the shapes. This granite marker with a plaque marks the entrance to the grotto (left). (Above, courtesy of Marie Cunningham; left, photograph by Steve Weiss/Candid Landscapes.)

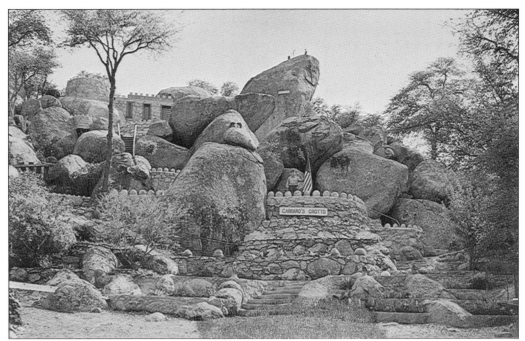

It is possible to see at least one animal in this postcard (above). Carraro is standing next to the flagpole. People often referred to Carraro's grotto as the "zoo of rocks." Carraro's house is visible in the top picture. Nestled in the rocks, the house could accommodate his narrow bed and basic living needs. The grotto incorporates some elements of castle walls, which delineate some of the walkways (below). (Above, courtesy of Marie Cunningham; below, photograph by Steve Weiss/ Candid Landscapes.)

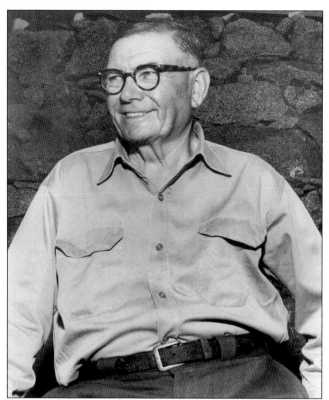

Carraro, that handsome Italian man, lived a solitary life in his later years (left). He and Silvia divorced in the late 1930s, and he never remarried. According to family members, Carraro was happiest by himself and a free spirit until he died. He is buried in Coloma, California. His former wife, Silvia, lived out her days in a house at 820 Paris Street, San Francisco (below). This picture taken in the late 1950s shows an interior room of that house. She too, never remarried. (Both, courtesy of Marie Cunningham.)

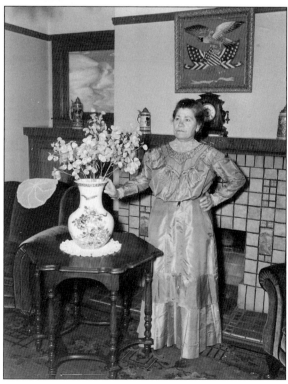

Three

THE CATTLE BARON

Edward Ambrose Tovrea, better known as E. A., was born March 20, 1861, in Sparta, Illinois. In 1883, he headed west, intending to haul freight between Ash Fork, Arizona, located on the Santa Fe Railroad, and Jerome, a nearby mining community.

E. A. married Lillian Richardson, the daughter of a freighter, and they had five boys. For a brief period of time they homesteaded land near Arlington, Arizona, which is southwest of Phoenix. E. A. and his brother J. C. later became meat suppliers during the construction of Wolfley Dam, later renamed Gillespie Dam. A failed business venture in the Buckeye (Arizona) Canal led E. A. to establish a butcher shop in Gila Bend, and later in Phoenix. He sold these holdings in 1898 and moved to Jerome, where he purchased an existing meat market and renamed it Tovrea and Clay. Around 1900, he moved to Bisbee, Arizona.

In Bisbee, E. A. purchased another existing butcher shop, Overlock and Company. He renamed it E. A. Tovrea and Company. Sometime in 1906, E. A. met Della Gillespie, a young girl from Texas. While it is unclear when E. A. divorced his first wife, Lillian, he and Della married in December 1906.

In 1919, E. A. and Della moved to Phoenix. E. A.'s newest business venture was the Arizona Packing Company, which he renamed the Tovrea Packing Company in 1931. Despite early financial and internal difficulties, the company grew and became well known for its emphasis on meat safety. As E. A.'s health declined in the late 1920s, he put his son Philip E. Tovrea in charge of the packing and cattle raising business. Philip went on to greatly enlarge the company over the ensuing years.

In June 1931, under wife Della's name, E. A. purchased the northeast quarter of the northwest quarter of section 8, which included the castle and the surrounding acreage. Unfortunately, he died February 7, 1932, and had little chance to enjoy it. According to the instructions in his will, E. A. wanted to be buried on the castle property. However, both the state and the county authorities prohibited that.

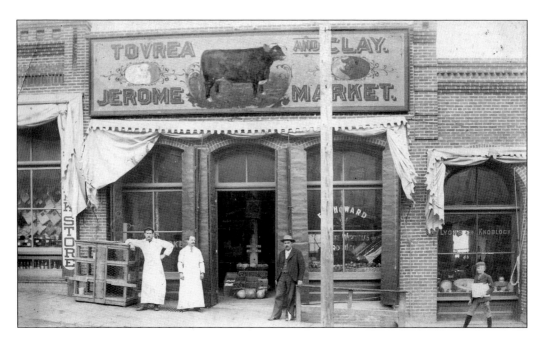

After trying his hand at being a meat supplier and owning a butcher shop in Gila Bend, Arizona, Tovrea briefly opened a butcher shop in Phoenix at 115 West Washington Street. In 1898, he moved to Jerome, Arizona, where he opened Tovrea and Clay Jerome Market (above). From the store sign, which features a steer, one might assume that it was a butcher shop. From the interior photograph below, however, it is obvious that Tovrea and Clay was a full-service market. Tovrea quickly became involved in this burgeoning community, being elected its first mayor shortly after he arrived. However, Tovrea sold his share of the market in 1900 and moved to Bisbee in the southern part of the Arizona Territory. (Both, courtesy of Philip E. Tovrea III.)

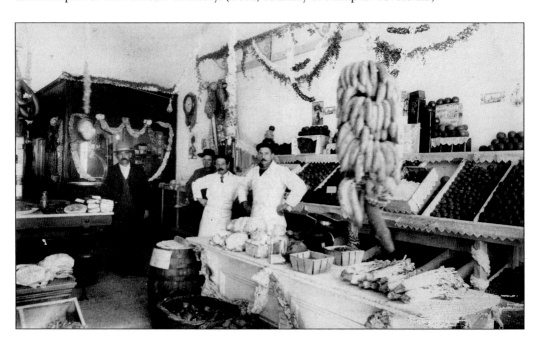

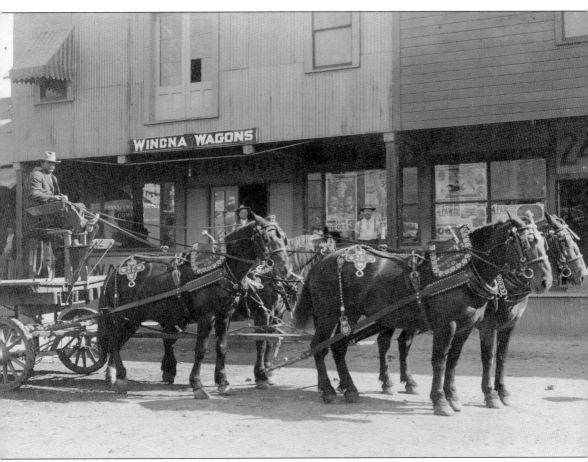

This is an undated picture of a wagon and team of horses owned by the Sonora Packing Company. The company name is marked on the elaborate horse rigging. Sonora Packing Company was headquartered in Cananea, Sonora, Mexico, with branches in Lowell, Bisbee, and Douglas, Arizona. E. A. Tovrea was the general manager. (Courtesy of Philip E. Tovrea III.)

Congress passed the Organic Act in June 1910, authorizing the territories of Arizona and New Mexico to seek statehood by first drafting a constitution. Out of the 52 delegates selected to the Arizona Constitutional Convention, 41 were Democrats. The delegates had 100 days to complete the constitution. Using the room where the Territorial House met (below), these men voted down along party lines. E. A. Tovrea is the third man from the right in the picture below, taken November 5, 1910, about a month before the convention adopted the constitution. (Both, courtesy of Arizona State Library, Archives and Public Records, History and Archives Division, Phoenix, #95-2488 and #02-0212.)

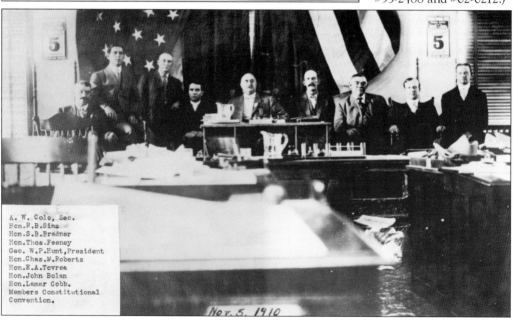

A. W. Cole, Sec.
Hon.R.B.Sims
Hon.S.B.Bradner
Hon.Thos.Feeney
Geo. W.P.Hunt,President
Hon.Chas.M.Roberts
Hon.E.A.Tovrea
Hon.John Bolan
Hon.Lamar Cobb.
Members Constitutional
Convention.

Nov.5. 1910

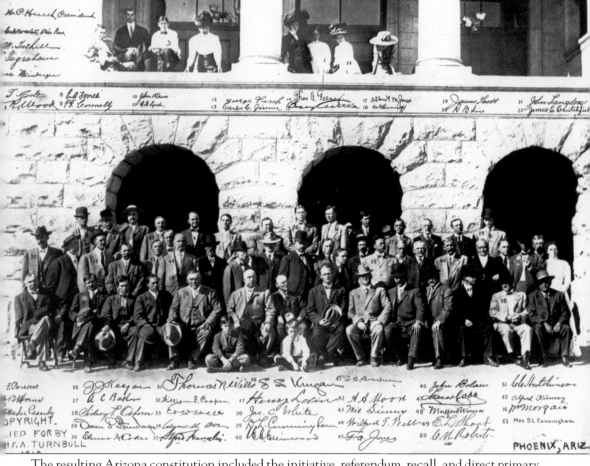

The resulting Arizona constitution included the initiative, referendum, recall, and direct primary, all elements reflecting the Progressive movement that was sweeping the nation. Congress adopted the Arizona Constitution, but President Taft objected to the section dealing with the recall of judges and vetoed it in August 1911. The Arizona delegates knew this would happen, but they wanted to voice the will of the people. Once recall of judges was deleted, President Taft signed the bill admitting Arizona to the Union on February 14, 1912. In the November election of that same year, the citizens of Arizona amended the constitution to allow the recall of judges and give women the right to vote. E. A. Tovrea is fifth from the left in the front row. George W. P. Hunt, the president of the constitutional convention and the man who would become Arizona's first governor, is seated to the right of Tovrea. (Courtesy of Arizona State Library, Archives and Public Records, History and Archives Division, Phoenix, #95-2489.)

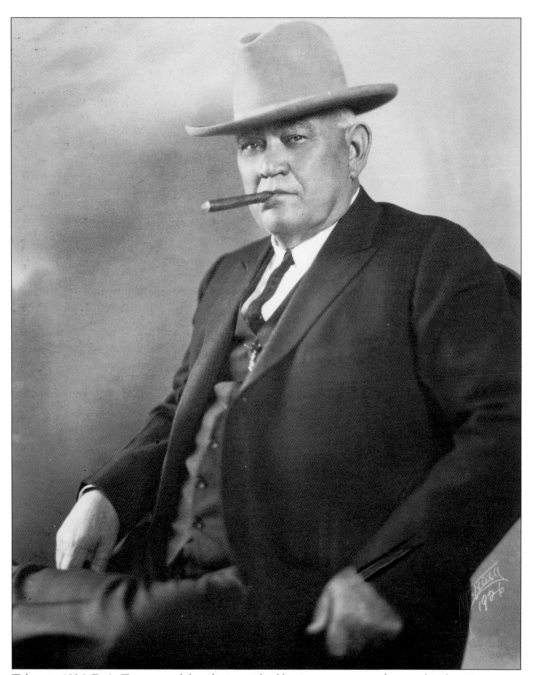

Taken in 1926, E. A. Tovrea models a distinguished business stature and sports his favorite item, a cigar. By this time in his career, he had served one year (1896) on the Territorial Livestock Sanitary Commission, participated in local and territorial political arenas, and created the beginnings of what was to become a large cattle-based empire. Tovrea sold his Bisbee meat shop in 1919 and moved back to Phoenix with his wife, Della. He founded the Arizona Packing Company, later renamed the Tovrea Packing Company. This cattle baron image of a man who started as a butcher perfectly matches with one of Arizona's Five Cs (copper, cattle, cotton, citrus, and climate). (Courtesy of Philip E. Tovrea III.)

Tovrea's son Philip Edward lived in California for a period of time. On one of those trips to visit Philip and his family in the mid- to late 1920s, E. A. posed in somewhat informal Western wear with his customary cigar (right). Whether on the same trip to California or another one, standing left to right below are E. A., one of his brothers, and Philip Edward Tovrea Jr. Seated is Helen Tovrea. (Both, courtesy of Philip E. Tovrea III.)

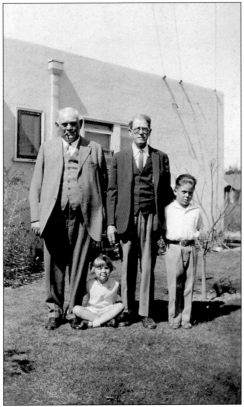

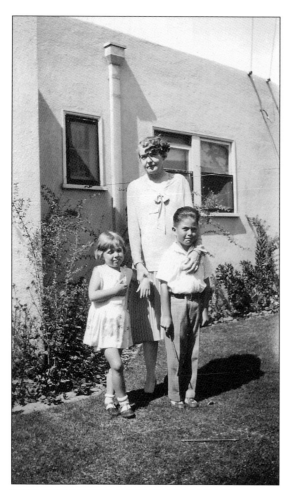

Stylishly dressed on a sunny day in California, Della stands between Helen and Philip Jr. (above). Based on the children's expressions, they may have grown tired of posing. Presumably taken in the front of Philip's house in California, the late 1920s photograph below features E. A. and Della with his two grandchildren, Helen and Philip Jr. (Both, courtesy of Philip E. Tovrea III.)

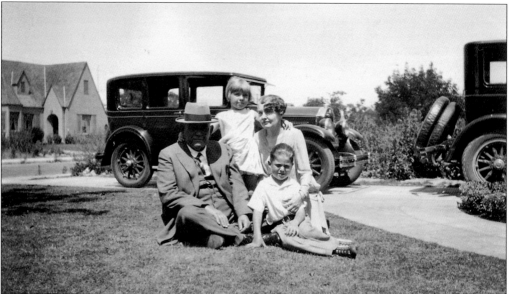

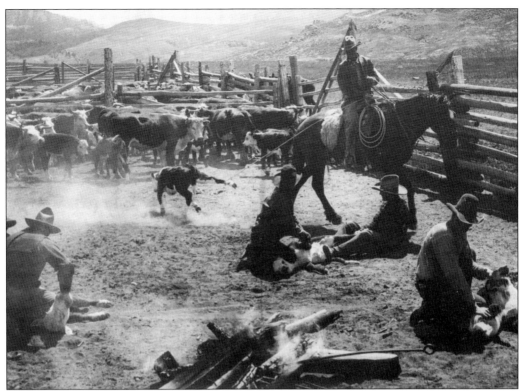

As the Tovrea Packing Company grew, so did the family holdings. At one time, the company owned a number of ranches. The Double O Ranch near Seligman, Arizona, had over 250,000 acres. Branding cattle (above) is something people naturally associate with the West. Cattle on the range such as pictured below were typical on many of the Tovrea-owned ranches. (Both, courtesy of Philip E. Tovrea III.)

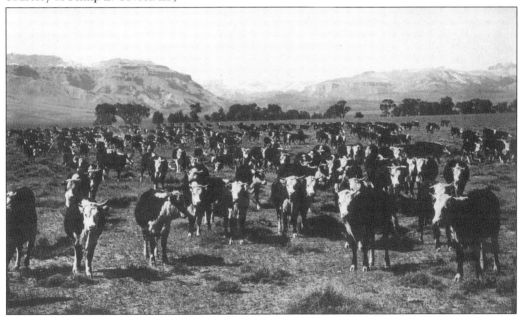

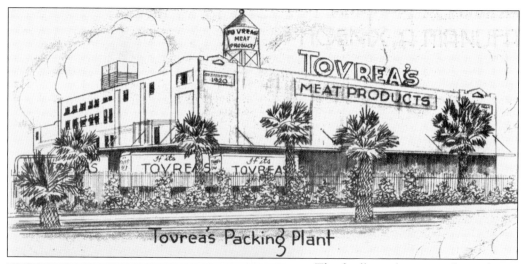

Tovrea's Packing Plant

TOVREA'S
Where livestock is
KING!

The feedlots adjacent to the packing plant could hold 30,000 head of cattle at one time in the 396 pens. The Tovrea Packing Company guaranteed quality meat. It owned farms to raise feed, feed-processing plants, ranches, feedlots, and the packing plant (above). The Tovrea Packing Company brochure clearly lets everyone know the importance of beef. (Above, courtesy of John Jacquemart; left, courtesy of Philip E. Tovrea III.)

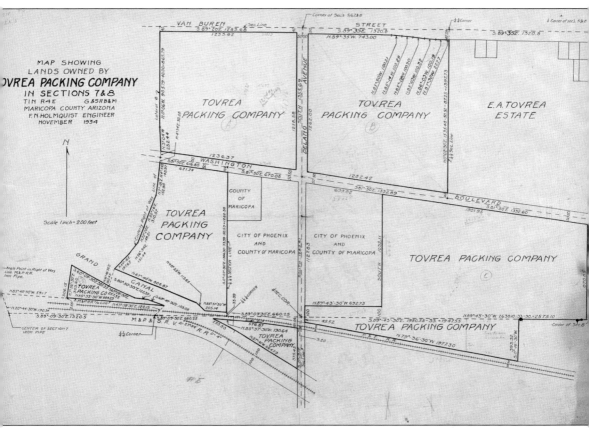

This 1934 map shows the land Tovrea Packing Company owned surrounding the castle property (listed as E. A. Tovrea estate on the map). Delano Avenue was surveyed in the 1920s and appears on the 1925 Warner Heights plat. As the city of Phoenix extended its limits through annexation, Delano Avenue would eventually become Forty-eighth Street. The properties marked City of Phoenix and County of Maricopa were vacant parcels at this time. (Courtesy of Philip E. Tovrea III.)

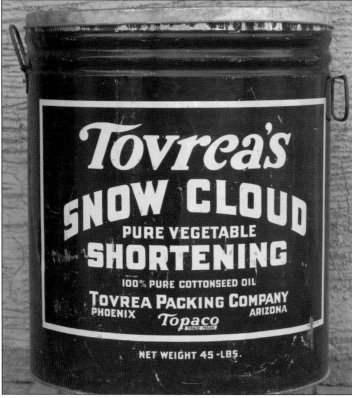

The undated photograph above was shot looking to the east with Camelback Mountain in the background. In the lower right side, just beyond the Sno Breze cooling system is a small sign marking the Tovrea Meats city office. The building was located at 137 East Monroe Street in Phoenix. The can of Tovrea's Snow Cloud Shortening (left) was one of many products the company produced and sold commercially. (Above, courtesy of Arizona State Library, Archives and Public Records, History and Archives Division, Phoenix, #97-0846; left, photograph by Donna Reiner.)

In the days when people were not concerned with fats and cholesterol in food, lard was a common cooking product. A four-pound can such as the one at right was a standard item in commercial operations such as restaurants and bakeries. An unidentified Tovrea child (possibly a great-grandchild of E. A.) uses a lard bucket while at the beach (below). The can made an ideal pail for sand and other beach treasures, along with being an inexpensive method of advertising the product on the outing. (Both, courtesy of Philip E. Tovrea III.)

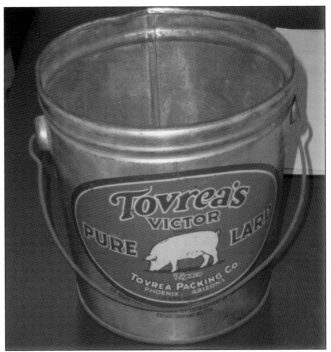

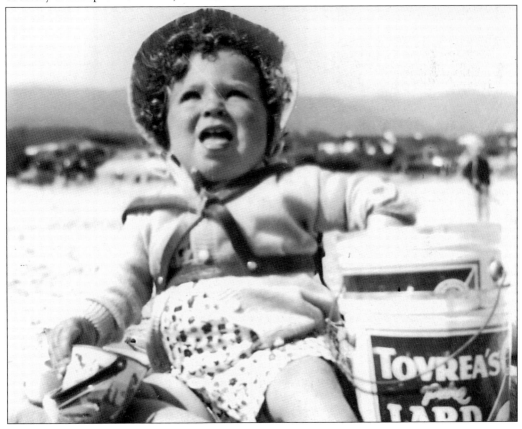

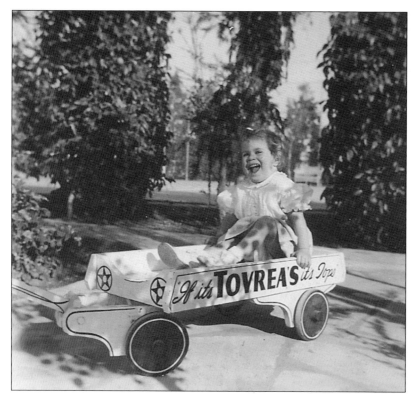

Judy Tovrea, sister of Philip Tovrea III, sits in a wooden wagon painted with a Tovrea Packing Company motto. Apparently the wagon with Judy in it was going to be used in a marketing program, but the ad promotion was pulled for some unknown reason. (Courtesy of Philip E. Tovrea III.)

Arizona Packing Company was the predecessor of Tovrea Packing Company. The shortened name and symbol was Aripaco, with an arrow through the word. This small can of Fenix (a play on the name of the city) was just another brand name of lard without stating so. (Photograph by Donna Reiner.)

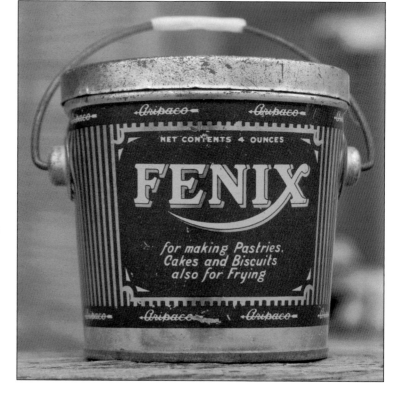

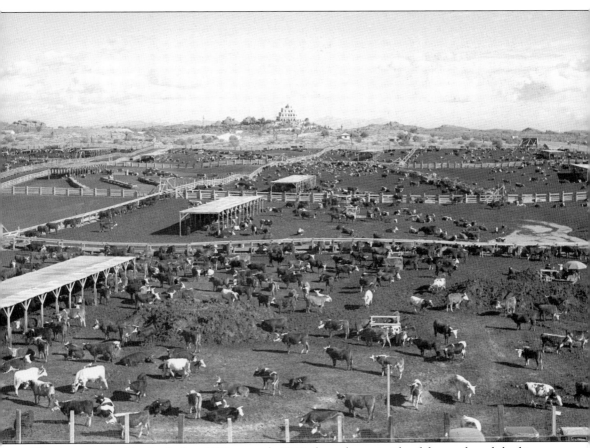

This image was taken in the late 1930s or early 1940s from the west side of the stockyards looking east. Tovrea Castle is clearly visible in the middle of the picture. While picturesque in a photograph, stockyards are notoriously smelly and have many flies. At one time, the Tovrea Stockyards touted itself as the largest in the world. This stockyard employed a custom feeding program that enabled the company to process over 300,000 head a year, 30,000 a day, using 8 miles of feeding troughs covering 175 acres. (Courtesy of Arizona State Library, Archives and Public Records, History and Archives Division, Phoenix, #97-1705a.)

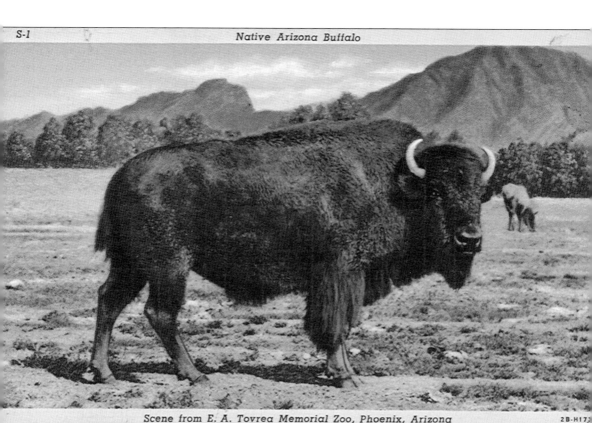

Scene from E. A. Tovrea Memorial Zoo, Phoenix, Arizona 2B-H17

The E. A. Tovrea Memorial Zoo opened June 21, 1942. Philip E. Tovrea opened the zoo as a tribute to his late father, founder of the Tovrea cattle business. The zoo was located on Washington Street on the north side of the Pueblo Grande Museum site, which was near the packing plant. The intent was first to provide a service to Phoenicians (no other zoo existed in the area), and second, to feature animals found in the southwest. Accounts suggest that there was an ambitious plan for the zoo to include two animals each of native Arizona wildlife. It is doubtful that this ever happened considering the war conditions. Pictured behind this buffalo is Camelback Mountain. Conflicting reports do not provide a clear idea as to when the zoo closed, but it is presumed to be sometime in late 1946. This postcard may be the sole reminder of what once was. (Courtesy of Donna Reiner.)

The expansive Tovrea Stockyards in 1949 lay just west of the castle in the upper right corner of the photograph on the right. One always knew which way the wind blew by the stench of the cattle manure. Van Buren Street (US Highway 60/80), cutting across the top of the photograph, was the major route to Phoenix from the east. The aroma must have had a dramatic impact on visitors as they drove by. The locals never got used to it, but learned to live with it. After all, cattle symbolized one of Arizona's Five Cs and were depicted in the state seal. The 1949 aerial view of Tovrea Castle below records the pristine desert landscape on its eastern side and much of its northern, but clearly shows more stock pens just south of Washington Street. (Both, courtesy of the Flood Control District of Maricopa County.)

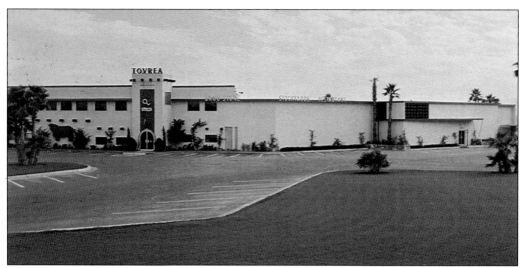

Although E. A. Tovrea died in 1932, the Tovrea empire" continued to grow and prosper under the leadership of his son Philip Edward Tovrea. Philip's son, Edward Arthur Tovrea, began building this two-story structure in 1953 as a replacement for the company's headquarters, which had burned earlier that year (above). The building also included a restaurant and an 1889-themed saloon that originally served cattlemen and employees of the Tovrea Cattle and Land Company. Today there is a fiberglass steer positioned on the roof over the doorway. The plate below from the high-class steakhouse shows a steer, symbolizing beef is food for a king (below). For a time, there was a pen of cattle near the restaurant with a sign that read, "Your Steak on the Hoof. Fed for Stockyards Restaurant." (Above, courtesy of Donna Reiner; below, courtesy of Philip E. Tovrea III.)

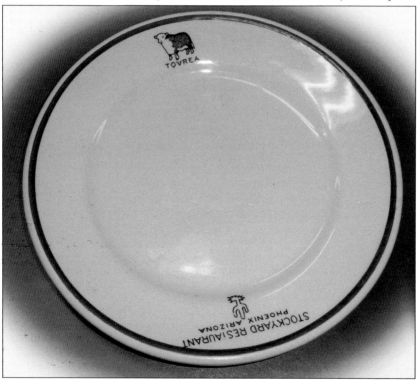

Four

DELLA

Born Della Gillespie in Blanco, Texas, on October 8, 1888, Della and her mother, Irena, moved to Bisbee, Arizona, in 1906. On December 26, 1906, she married E. A. Tovrea, a 45-year old divorced man with four living sons. The couple later moved to Jerome, Arizona, and several other Arizona towns before permanently settling in Phoenix in 1920. They briefly lived in central Phoenix before E. A. built a home on the property by the meatpacking facility.

Following E. A.'s death in February 1932, Della spent most of the warm summer months in Prescott, Arizona. There she frequently encountered William Plato Stuart, a neighbor and friend, who was the editor of the *Prescott Evening Courier*. He was divorced with a married daughter who lived in Pasadena, California. Della married Stuart on November 16, 1936, in Las Vegas, Nevada. They subsequently moved back and forth between her home on Pleasant Street in Prescott and the castle in Phoenix.

Della made a number of improvements to the grounds of the castle. Using the gardens designed by Motka as a basis, she expanded plantings on the east side and added outdoor living spaces.

Both Della and William were active in the Democratic Party on the state and national level. Della was the only woman delegate from Arizona at the Democratic National Convention in 1936 and was elected Democratic National Committeewoman from Arizona, a position she held from 1940 to 1956.

Following the death of her second husband, Della hired a number of caretakers for the property. She also spent more time with her divorced sister, Ima Rutherford, who lived in Teague, Texas. Ima was due for her annual visit to Phoenix on November 14, 1968. However, burglars broke into the castle the evening before that visit, stole a large amount of jewelry and cash, and tied Della up. Then 80 years old, Della's health declined rapidly after the ordeal, and she died January 17, 1969.

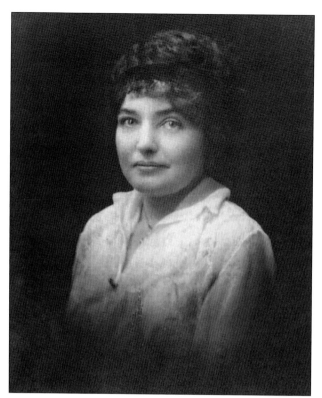

This undated portrait of Della (left) may have been taken shortly before she married E. A. Tovrea in 1906, as family records identify her here as Della Gillespie. Family stories conflict with other writings as to what Della did in Bisbee before marrying E. A. One suggests that she was a saloon girl, another that she worked in Tovrea's butcher shop. The date and place of this picture of Della are unknown (below). Based on the early-20th-century architecture of the room and Della's dress, the photograph may have been taken in one of the two homes in which the Tovreas lived in Bisbee, Arizona. (Both, courtesy of Philip E. Tovrea III.)

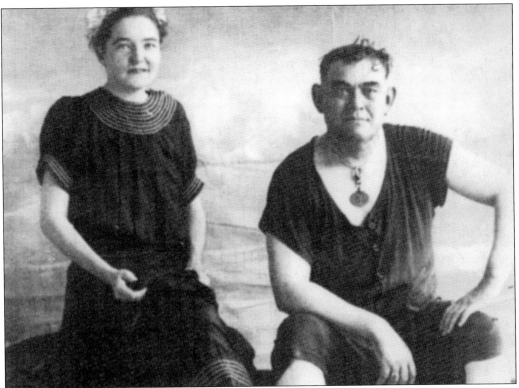

Della and E. A. pose in their swim attire, stylish for the day but rather impractical in today's world. The picture may stem from a trip to Coronado, California, a favorite beach vacation spot for Phoenicians or from one of their trips to visit E. A's son Philip in southern California. (Courtesy of Philip E. Tovrea III.)

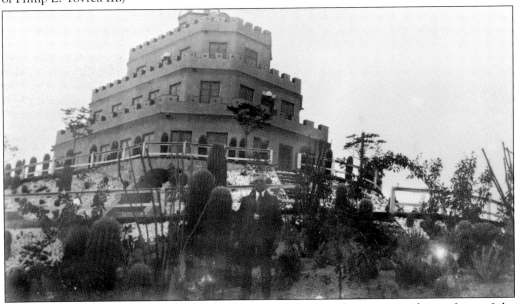

This undated photograph shows William Stuart standing in the cactus garden in front of the castle. Stuart was Della's second husband. (Courtesy of Philip E. Tovrea III.)

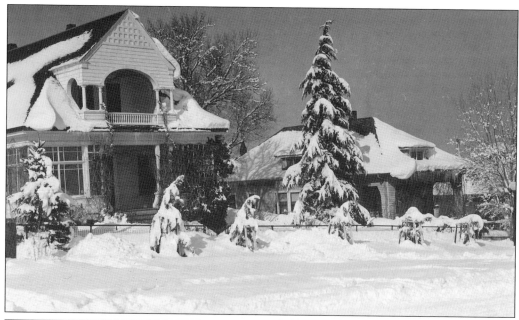

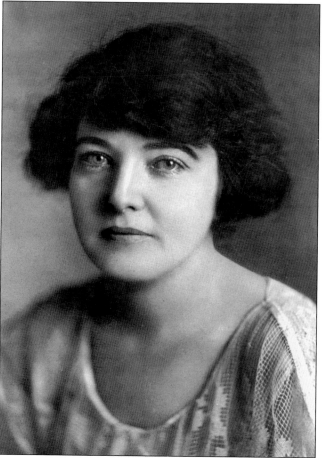

Prescott, Arizona, is located in the Bradshaw Mountains approximately 100 miles north of Phoenix. Prescott was a place where many Phoenicians escaped the summer heat since its elevation was nearly 5,400 feet. It offered cool breezes blowing through pines and certainly much cooler daytime temperatures. Della's house (above, on the left) on the corner of Goodwin and Pleasant Streets (146 South Pleasant Street) in Prescott was where she retreated after the death of her husband, E. A., in February 1932. E. A. had purchased this house as a summer home around the same time as the purchase of the castle. The house, later referred to as the Tovrea/Stuart home, burned sometime in the 1960s. This winter shot shows all that remained. The undated photograph of Della at left was presumably taken during one of her periods of residence in Prescott. (Both, courtesy of Sharlot Hall Museum Photos, Prescott, Arizona.)

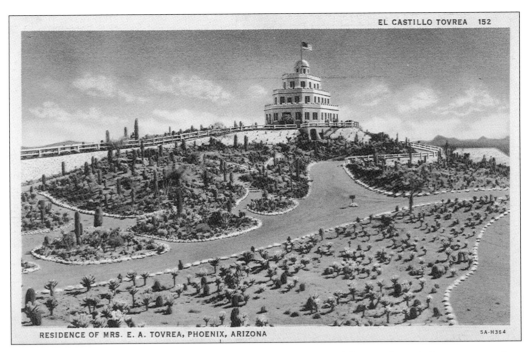

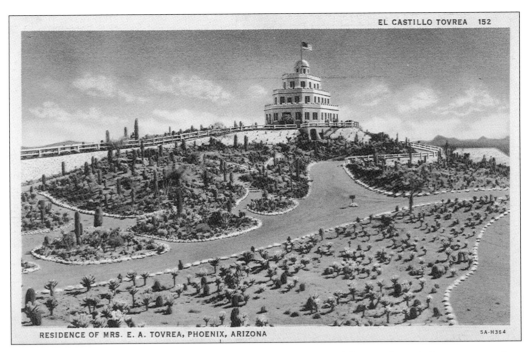

EL CASTILLO TOVREA 152

RESIDENCE OF MRS. E. A. TOVREA, PHOENIX, ARIZONA 5A-H364

The tinted postcard above portrays the most common view of the castle and the cactus garden, the view people would see as they traveled to the east on Van Buren Street (US Highway 60/80). Della authorized a California company to print hundreds of these postcards titled "El Castillo." Taken on a beautiful sunny day in Phoenix, the photograph postcard below shows the castle from the Washington Street side looking north. Several mature saguaro cacti stand guard at the entrance with their multiple arms. Much younger cacti, which Della had planted, line the stone wall. (Above, courtesy of Donna Reiner; below, courtesy of City of Phoenix.)

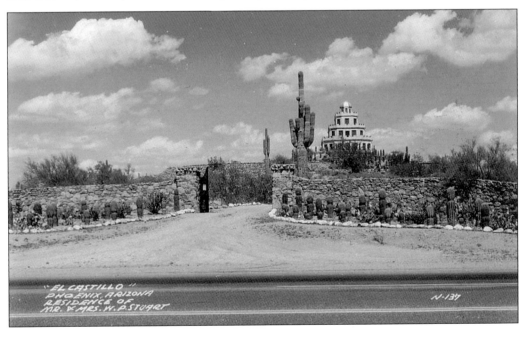

"EL CASTILLO"
PHOENIX, ARIZONA
RESIDENCE OF
MR. & MRS. W. P. STUART N-137

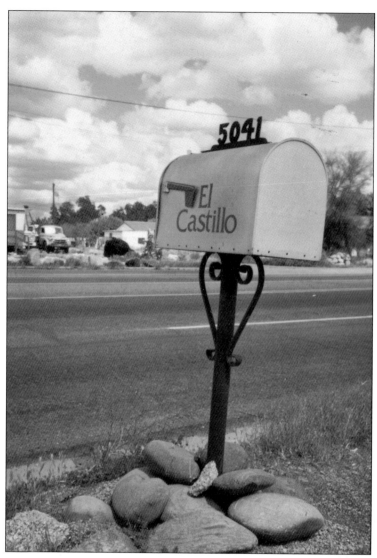

Della referred to her home as El Castillo, even going so far as to have it indicated on the mailbox (left). After E. A. died in February 1932, she maintained the castle as her Phoenix winter residence until the retirement of her second husband in 1958. At that point, Della and William moved into the castle on a permanent basis. William died in 1960. Typical of the time, Della frequently corresponded with friends and family. Her stationery was distinctive with its printed image of the castle (below). A Mrs. Langmade was one of Della's friends and virtually lived down the street from the castle. (Both, courtesy of Philip E. Tovrea III.)

THE W. P. STUARTS
POSTOFFICE BOX 2374
PHOENIX, ARIZONA
85002

Mrs. L. Langmade
4802 E. Van Buren St.
Phoenix, Arizona 85008

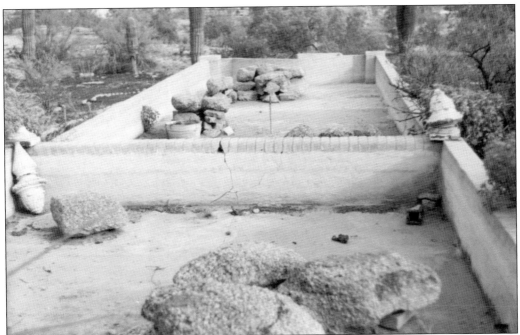

During the nearly 40 years that Della lived at the castle, the cacti in the formal west garden grew. The stately saguaro created an imposing image from the surrounding roads. Della also added a number of features. The mortarless stone wall around the 44 acres is the most visible to those who pass by. On the east side of the castle, she added a rose garden, an aviary, a 12-foot-by-60-foot reflecting pool (above) that probably had a pergola, and a patio with a granite fire pit. She left the game court and horseshoe area that Carraro had installed on the south and east side of the castle (below). The property was able to connect to the city water system in 1940, which made it easier to water the gardens and certainly increased the water pressure. (Both, courtesy of Marie Cunningham.)

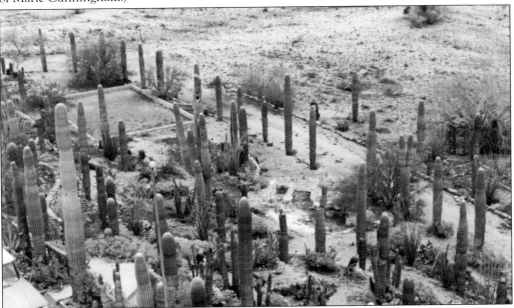

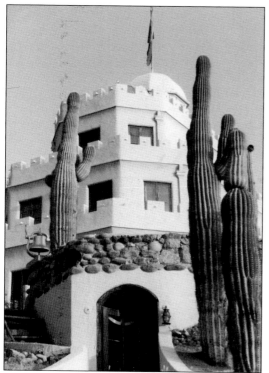

Della created a more formal patio area immediately surrounding the castle. She had concrete poured to replace the crushed granite Carraro had installed. A large bell that apparently E. A. had obtained from a Jerome locomotive was mounted on the patio wall near the front door (left). Philip Tovrea III stands below the rock wall surrounding the upper patio. Della included petroglyphs to add interest in the wall below. (Both, courtesy of Philip E. Tovrea III.)

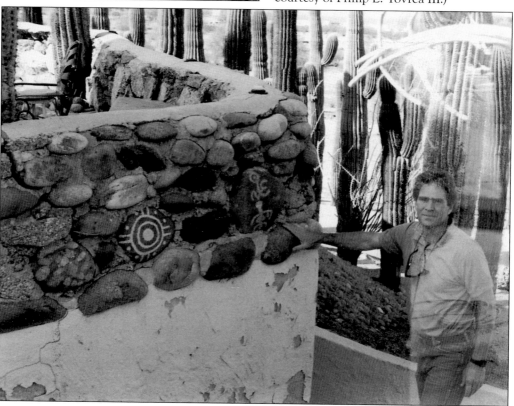

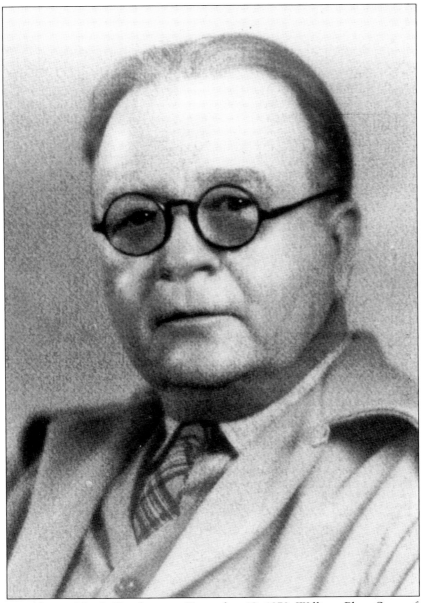

Born in Snow Camp, North Carolina, on December 18, 1879, William Plato Stuart fought for Cuban freedom in 1896, eventually came to New Mexico to punch cattle, and later to Arizona to work in the mines. Stuart tried his hand as a newspaper stringer and turned to journalism full-time in 1912, taking a job with the *Los Angeles Tribune*. After a year there, he returned to Phoenix, becoming editor of the *Arizona Democrat*. Stuart had several more stints with California and Arizona newspapers before becoming editor of the *Prescott Courier* in 1920 and its publisher in 1921. Stuart built the *Courier* from the town's secondary newspaper into the dominant one, later purchasing its competitor, the *Journal-Miner*. Stuart was a political power in Arizona for many years. While he never sought public office, Stuart was the U.S. internal revenue collector for Arizona from 1937 to 1955. Although he was a Democrat, he held the respect of numerous Republicans. Stuart died in the castle November 26, 1960, at the age of 81. He was elected to the Arizona Newspapers Hall of Fame in January 1969. (Courtesy of Philip E. Tovrea III.)

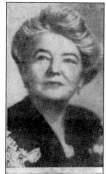

Della was heavily involved in the Democratic Party on the local and national levels. She began her political "career" when she was elected as the sole woman representative from Arizona to the 1936 Democratic National Convention. As she became more involved, Della regularly attended the Arizona state Democratic conventions in her role as the Democratic National Committeewoman, where she is pictured above on March 22, 1948. She held this position from 1940 to 1956. She did her part by raising money too. In 1943, she raised over $200,000 during the third war loan drive by holding a $1,000-per-plate meal at El Castillo. Over 200 people attended. Many meetings took place in Washington, where she and husband William Stuart frequently traveled. Della is pictured below, on the right, with India Edwards October 13, 1947. Edwards served in leadership positions in the women's division of the Democratic National Committee before she was elected the vice-chairwoman of that committee in 1950. (Both, courtesy of *Prescott Evening Courier*.)

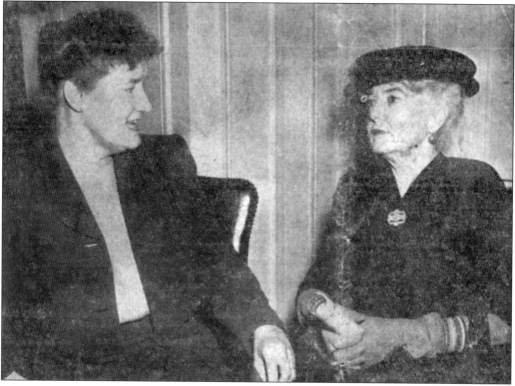

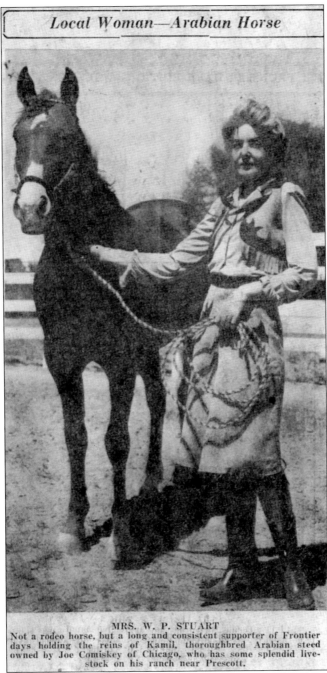

Local Woman—Arabian Horse

MRS. W. P. STUART
Not a rodeo horse, but a long and consistent supporter of Frontier days holding the reins of Kamil, thoroughbred Arabian steed owned by Joe Comiskey of Chicago, who has some splendid livestock on his ranch near Prescott.

Prescott Frontier Days is a major event in Prescott, Arizona. The name first appeared in 1913 when the annual rodeo moved to its permanent arena: the Yavapai County Fairgrounds. The Prescott Rodeo began July 4, 1888 and is billed as the world's oldest continuous rodeo as it never ceased operation even during wartimes. It was only natural that the permanent and summer residents were eager to celebrate both the rodeo and the country's birth. In this June 27, 1944, newspaper photograph, Della is appropriately dressed in western attire. (Courtesy of *Prescott Evening Courier*.)

This early 1930s photograph shows the entire enrollment of the students who attended Balsz Elementary School. Leo Carraro, son of Alessio, attended this school and may actually be in the photograph. The school is located within a mile of Tovrea Castle. While Della did not have any

Della was actively involved in the businesses of both her husbands. Following E. A.'s death in February 1932, she was elected as a director of the Tovrea Packing Company. She served as secretary and treasurer of the *Prescott Courier* for a brief time, the newspaper her second husband, W. P. Stuart, owned. Stuart also owned the Central Arizona Broadcasting Company, which operated a radio station in Jerome, Arizona. Della served as its president from 1937 to 1944. Sitting at this desk, she diligently attended to business affairs. (Courtesy of Philip E. Tovrea III.)

children of her own, the Della Tovrea Stuart Scholarship provides monetary support for residents and graduates of the Balsz School District who attend Arizona State University. (Courtesy of Marie Cunningham.)

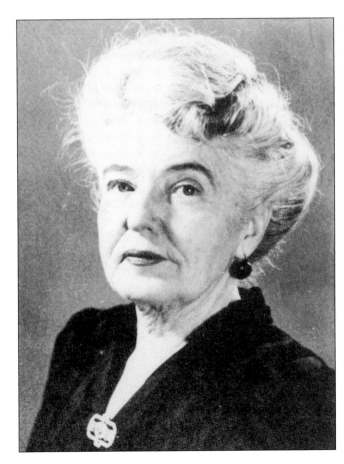

This undated photograph of Della was often used in publicity materials. (Courtesy of Philip E. Tovrea III.)

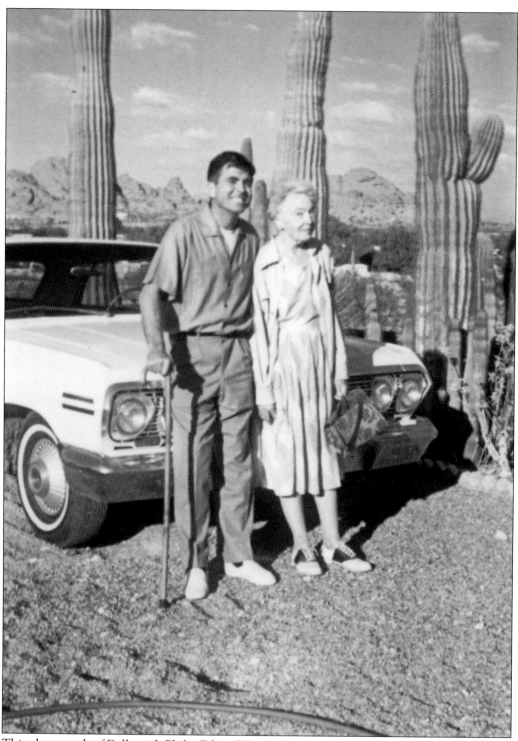

This photograph of Della with Philip Edward Tovrea Jr. was taken on the castle grounds in front of a 1963 Chevrolet. The signature saguaro are a few of the many cacti planted at least 30 years before. (Courtesy of Philip E. Tovrea III.)

Della and her two husbands rest in Section 34 of Greenwood Memory Lawn Cemetery on East Van Buren Street in Phoenix. Section 34, the Tovrea family plot, is a small circular area surrounded by tall trees. E. A. Tovrea's headstone (above) and W. P. Stuart's (below) lay flat to the land. Tovrea died of pneumonia at the age of 70. Stuart died at the age of 81. Since Della's husbands preceded her in death, it can only be surmised that it was she who decided that her name be carved on both of their headstones. (Both photographs by Donna Reiner.)

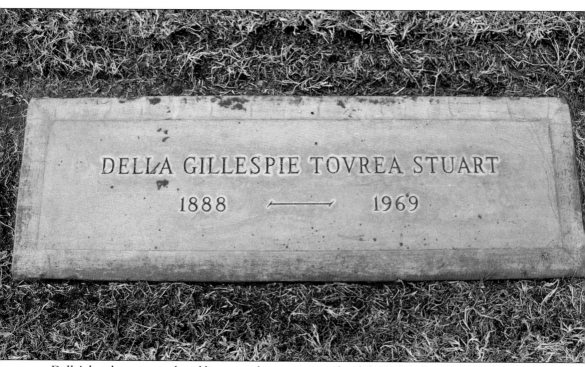

Della's headstone was placed between the two men in her life. Della's death has as many oddities as her life. Della's habit in the summer months was to sleep in the cool basement. As she aged and continued to live alone in the castle, she became more fearful and slept in the kitchen with a gun beside her. One evening burglars broke in looking for, and finding, money and jewelry. She managed to get off at least one shot from her gun and the hole in the kitchen ceiling remains as proof. Articles and reports prior to this incident indicate that she was not opposed to using a gun to scare prowlers or trespassers. (Photograph by Donna Reiner.)

Five

A STATE OF LIMBO

Oversight of the castle and the surrounding property reverted to the Tovrea family trust in 1970 following Della's death in early 1969. At various times, caretakers lived onsite, but were primarily there to protect the castle from vandalism. Philip E. Tovrea III lived in the castle for extended periods, making some repairs to the building. It was during his stays time that more people were able to visit the site and thus more photographs are available of both the interior and exterior.

The delicate gardens were left to the whims of nature for the next 25 years. Droughts and/or heavy rains, disease, and the voracious appetites of rabbits gradually took their toll. The saguaro particularly suffered from overcrowding, as Mokta apparently did not understand that in a natural setting, saguaro would never grow as close together as he had planted them in his garden area.

Development surrounding the property increased and placed pressure on the Tovrea family trust to do something with the castle. The stockyards eventually disappeared, and in their place came a U.S. postal handling station. Housing and other business ventures began to crop up on both Washington and Van Buren Streets. Yet the castle property clearly defined by the approximately three-foot wall kept the outside world at bay. Nevertheless, the castle continued to pique the curiosity of visitors and residents, who wondered about the "wedding cake" building.

The Tovrea family considered development of the property at one time, but fortunately no formal action began. In part this may have been a result of the granite formations, which would have made it extremely difficult and expensive to build apartments or condominiums. This indecision may also have resulted from not being able to come to a consensus. Eventually the Tovrea family decided to dispose of the nearly 44 acres containing the castle in the late 1980s, and thus the City of Phoenix began discussions with the family about the possibility of acquiring the property.

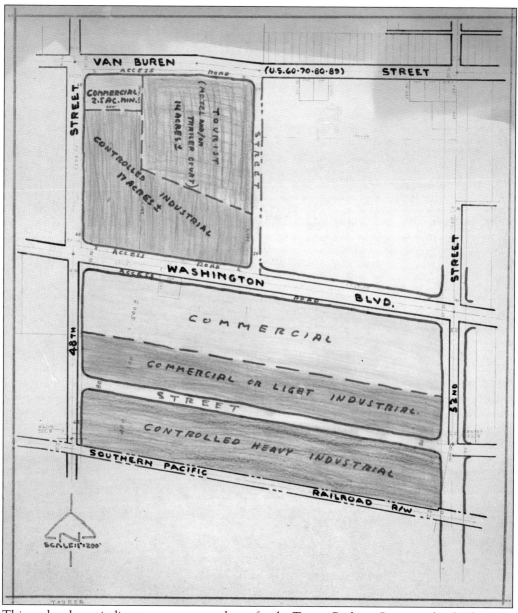

This undated map indicates some proposed uses for the Tovrea Packing Company land. The most common use would be commercial or light industrial. However, a hotel or perhaps a trailer park was suggested for a portion of the property that fronted Van Buren Street, since it was the major highway across the valley. The blank area on the right side of the map is the location of the castle and its surrounding grounds. The proposed north/south street between Forty-eighth and Fifty-second Streets was never put in, nor was the street running east/west to the south of Washington Street. The mapmaker incorrectly inked "Boulevard." (Courtesy of Philip E. Tovrea III.)

Looking west, this photograph shot from the patio area by the front door of the castle shows the machine shop in the foreground (above). This building is clad in sheet metal, a material with which Carraro had made his fortune in San Francisco. The small, light-colored building to the right was the former workers' quarters when the castle was under construction. The vacant land is the site for the new U.S. Post Office handling station. The tall buildings in the distance mark the uptown area of Phoenix. Looking a bit to the southwest, the photograph below shows a water tower, a remnant of the stockyards. The tall buildings in this picture are the downtown core of Phoenix. (Both, courtesy of Philip E. Tovrea III.)

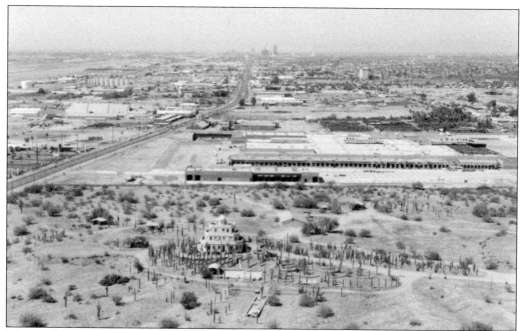

The castle is in the foreground of this early 1980s photograph looking west (above). Washington Street is the major road on the left side of the picture. The large building under construction is the U.S. Post Office handling station. It sits on the land formerly occupied by a portion of the stockyards, which had been removed by the late 1950s. (Courtesy of Philip E. Tovrea III.)

Time has taken its toll on the mortarless rock wall surrounding the castle property. Despite its type of construction, it is generally stable. Still, it is an ongoing project to maintain. (Courtesy of Philip E. Tovrea III.)

In 1979, a large sign (above) posted on the property announced that the mysterious Tovrea Castle would be open to the public "possibly for this time only." While the castle itself would not to be open, access to the grounds would provide an opportunity for Phoenicians to get close to it. Erroneously billed as one of the oldest landmarks, it actuality was meant to say the brightest landmark. The response was overwhelming—so much so that the crowds caused damage to the delicate desert vegetation. The brightest landmark label came from the decorative lights Philip III put up at Christmas, honoring the tradition that Carraro started and Della continued (below). (Above, photograph by Donna Reiner; below, courtesy of Philip E. Tovrea III.)

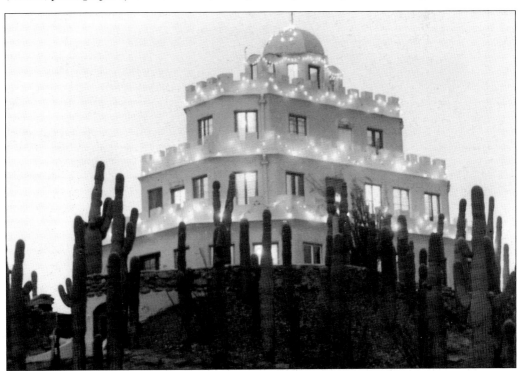

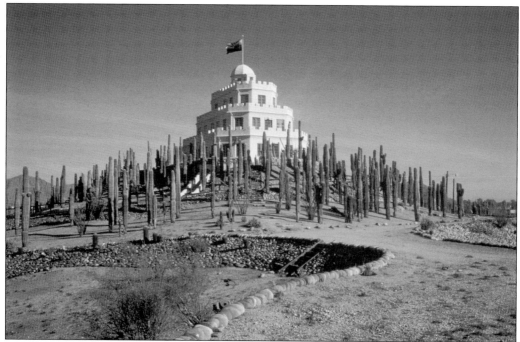

The saguaro cactus, a signature plant on the grounds and particularly close to the castle, is found only in the Sonoran Desert. The largest cactus in the United States, the ones found in the garden area are quite old, as the plant grows slowly. The rocks lining the trail lost their white paint over the years (above). Although saguaro may grow branches or arms that generally curve upward, many remain columnar their entire lives. Other vegetation common to the Sonoran Desert and found on the property includes palo verde (the Arizona state tree), ocotillo, brittle bush, desert marigolds, various cholla, and mesquites (below). When the palo verde bloom in the spring, the yellow blooms are vibrant. (Both photographs by Steve Weiss/Candid Landscapes.)

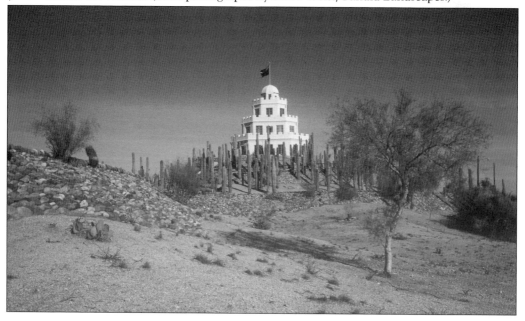

In this image from the east side of the castle, the two saguaro cacti appear to guard the castle. The cacti bases reveal some of the damage to the plants, probably inflicted by rabbits and ground squirrels. The natural vegetation fared rather well without regular care. But some of the distinctive saguaros died over the years, in part because they were planted in granite, which is not their normal environment. (Photograph by Steve Weiss/Candid Landscapes.)

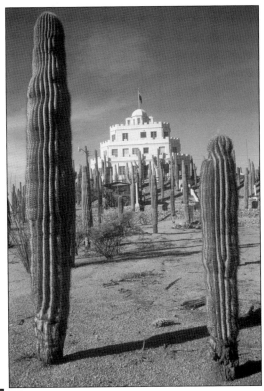

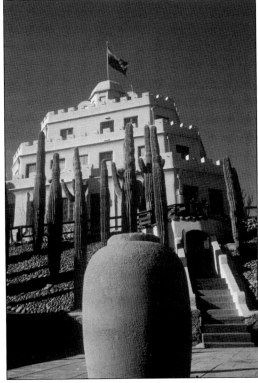

Della added these decorative concrete urns throughout the garden area. This is one of several urns mounted around the lower patio area on the east side of the castle. (Photograph by Steve Weiss/ Candid Landscapes.)

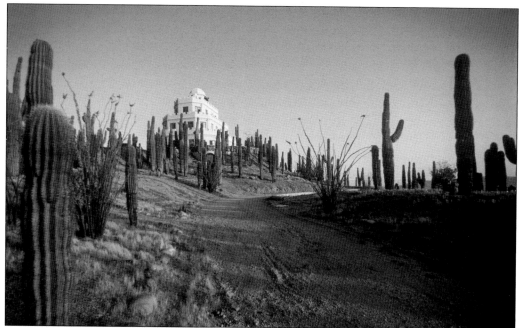

Nearly everyone who visited the grounds made sure that the castle was in their photograph. The photographer who took this image shot it from the road that meanders through the cactus garden. The framing makes the castle look like a ziggurat with its stepped stories. This small bit of desert brings a sense of solitude to Phoenix. (Photograph by Gregory Davis.)

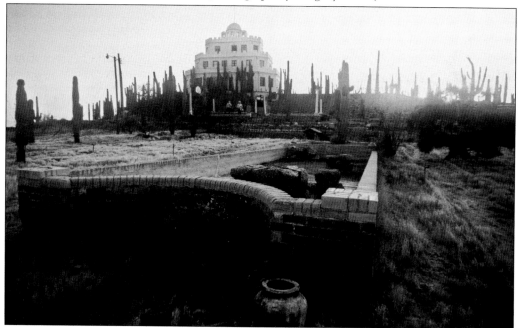

Shot at dusk by the brick reflecting pool, the castle towers over the cacti. Based on surviving evidence of tubs of earth in the pool area, water lilies may have grown in the pool. One of the concrete urns sits on the ground, having come off its pedestal. Della's nearby rose garden is only a vague memory, and no pictures of it seem to exist. (Photograph by Gregory Davis.)

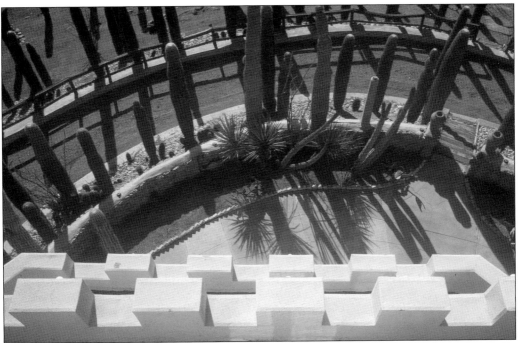

Two views from the upper level looking down clearly show the Tovrea Castle battlements. In medieval times, this was a type of defensive architecture. From behind the notched parapet, the defenders of the castle might shoot arrows or other missiles at the enemy. Stories from this castle suggest that guns were used from the battlements to shoot rabbits or coyotes. The sentinel-like saguaro cacti surround the castle patio and walkway appearing to add another layer of protection. (Both photographs by Steve Weiss/Candid Landscapes.)

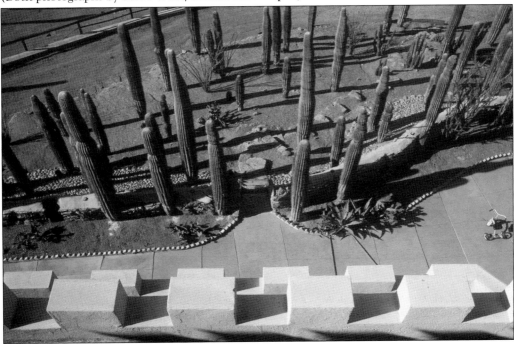

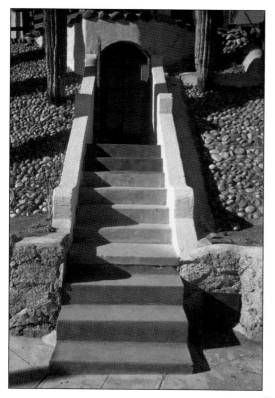

The basement of the castle has four doors at what can be considered the corners of the octagonal building. Each entrance is slightly different. One has steps leading into the garden (left). Entering any of the three arched doors from the outside, the visitor encounters a vaulted concrete block tunnel before coming to the spacious and cool basement (below). On the reverse, walking through any of the three tunnels from the basement to the outside, suddenly a magnificent view of the valley landscape and castle gardens appears. The southeast door had steps leading down to it from the south terrace of the first floor. The northeast tunnel opened just above the lower patio area that Della created. Each doorway view is dramatically different from the others. (Both photographs by Steve Weiss/Candid Landscapes.)

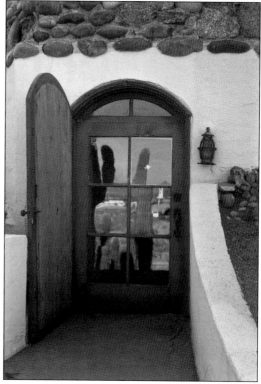

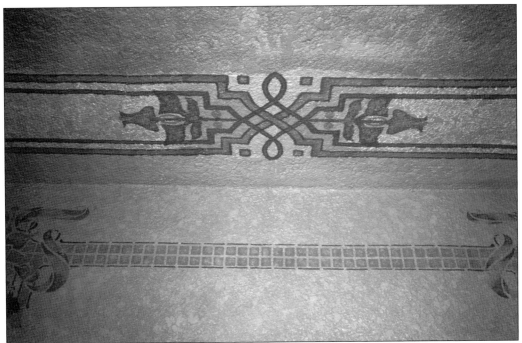

Ornate stenciling decorates the top of the walls of the two main rooms on the castle's first floor. They are quite distinctive on the textured walls. This is a portion of the elaborate design found in the great room, which contains the fireplace. (Photograph by Steve Weiss/Candid Landscapes.)

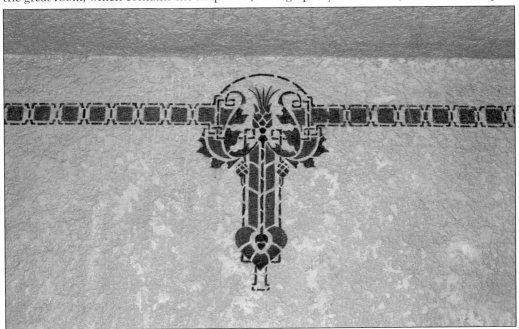

This stencil design is found in the entry room. Looking closely, hearts, leaves, and perhaps pineapples are apparent. As a symbol of hospitality and welcome, the pineapple motif certainly would be appropriate in this room, where guests most often entered the castle. (Photograph by Donna Reiner.)

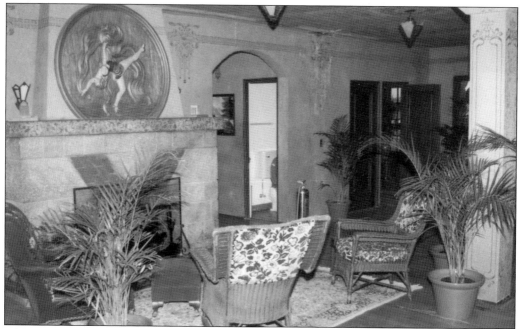

Although furnishings in this room belonged to Della, the picture was taken during the time that Philip Tovrea III lived in the castle (above). Visible in the hallway is the room with a toilet. There was an adjoining room with a sink. The double swinging doors toward the right side lead to the kitchen. Note the stenciling on the pillar. The kitchen sink (below) is a brilliant blue color. It is not known whether Carraro purchased the sink new or salvaged it from another building. It is probably the most memorable item in this room except for the bullet hole in the ceiling. That is the remaining evidence of when burglars broke in and beat Della in 1968. (Both, courtesy of Philip E. Tovrea III.)

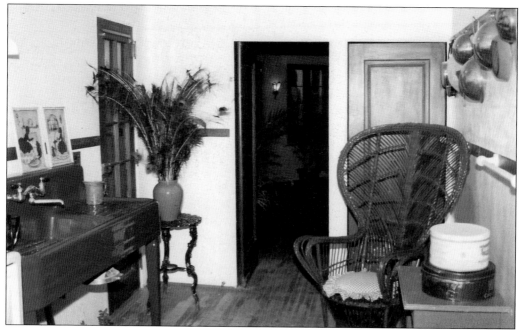

This 1970s photograph of the second-floor hallway gives the sense of how narrow it is. On the right is the only staircase to the third floor, and just behind it is the staircase from the first floor. From this view one cannot envision the odd shapes of the six guest rooms. Two rooms had sinks, and there was one full bathroom for the guests to share, a European-style arrangement. The two rooms on each side of the south end (the visible doorway) could be opened like a suite. The doorway went out to the veranda; a second doorway is behind the photographer. The third floor had two guest rooms that shared one full bath. The cupola was for guests to view the spectacular landscape. (Courtesy of Marie Cunningham.)

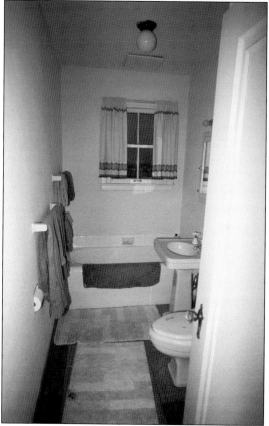

This 1983 picture of a second bedroom (above) is one of the end rooms. The exterior wall mirrors the angular shape of the building. The door, which does not go to the floor, covers the closet. While there is no stenciling on the walls, the rooms each have an art deco etched glass ceiling light. The second-floor full bath below features plumbing fixtures that date from the late 1940s, when Della made improvements to the property. This was the only full bathroom on that floor, so guests would have shared this facility. Of the six rooms on this floor, the two middle ones had sinks. (Both photographs by Gregory Davis.)

The staircase between floors two and three and three and four have an "L" shaped plan. This photograph shows the third-floor landing with its balustrade. Based on current codes, none of the stairs meet the required width, and the handrails are too low. But at the time of construction, such codes did not exist. (Photograph by Gregory Davis.)

This photograph was taken during the 1983 Dons of Arizona tour of the castle. Perhaps only one other person besides the unidentified woman and the photographer could fit in this cupola space. The low wall with its wood coping serves as a guardrail. The door leads to the battlement surrounding the cupola. (Photograph by Gregory Davis.)

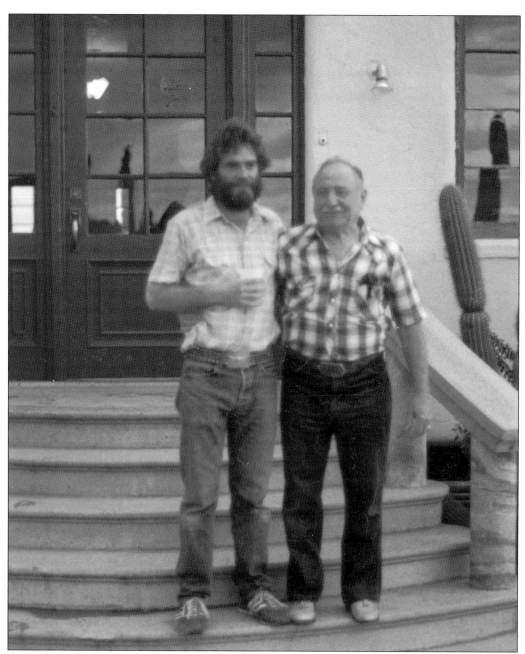

This mid-1980s photograph of Philip E. Tovrea III (left), great-grandson of E. A. Tovrea and Leo Carraro (right), son of Alessio, shows them standing on the front steps of the castle. These terrazzo steps provided a grand entrance to the first floor of the former hotel. Leo was born in Sonoma, California, where his father briefly worked as a cobbler. The Carraro family eventually moved back to San Francisco, where Alessio and Silvia had married. Leo spent most of his teen years in Arizona. During World War II, he served in the navy. Following that he opened Leo's Rite Inn, a tavern, and eventually owned two motels in Phoenix. Leo died January 5, 2001. Like his great-grandfather before him, Philip E. Tovrea III served as mayor of Jerome, Arizona. (Courtesy of Marie Cunningham.)

The castle meets the modern aeronautical world. Taken in the mid-1980s, the man standing next to the helicopter, Ed Spelts, is the great-grandson of E. A. Tovrea. He is the son of Dr. Helen Tovrea Spelts, who was the daughter of Philip Edward and Helen Green Tovrea. (Courtesy of Philip E. Tovrea III.)

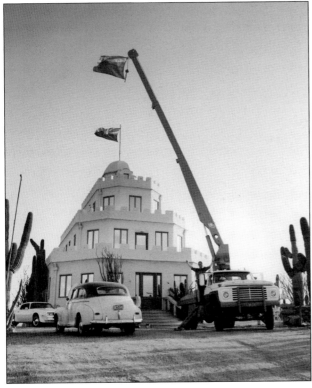

Philip Tovrea III operates a business in Jerome, Arizona, which requires the use of heavy equipment. Having just fixed the springs on his crane in Phoenix, it seemed like fun for him to pose for a picture with it in front of the castle. The older car belonged to Philip too. (Courtesy of Philip E. Tovrea III.)

Della loved clothes, jewelry, and fancy cars, and she saved everything. Items from the Depression era to the 1960s were available in an estate sale; Sharlot Hall Museum in Prescott, Arizona purchased some of her clothing. The museum mounted three exhibits in 1981 and 1982: one of her formal and informal wear, another of winter wear, and a third of warm-weather clothes. The formal wear was probably worn at political functions held in Washington, D.C. This display of Della's clothes, held in the basement and first floor of the castle, was a fundraiser for the Arizona Historical League in April 1983 with the assistance of Sharlot Hall Museum. It included a castle tour. Notice the bank vault which Della used it as a place to store her furs and valuables. (Both, courtesy of Philip E. Tovrea III.)

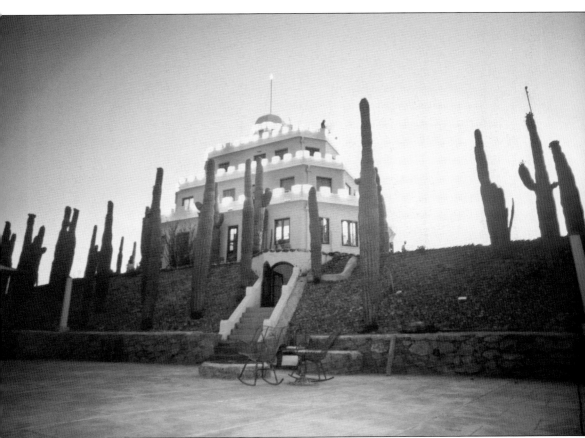

Based in Phoenix, Arizona, the Dons of Arizona is a nonprofit service organization that originally formed in 1931 as the Triangle Club through the Phoenix YMCA. Members of this organization were interested in the history and lore of the Southwest and therefore adopted a name that more aptly reflected that interest. The group soon separated their connection with the Y. In the spring of 1983, the Dons arranged for a private tour and party at Tovrea Castle through a member's friendship with Philip Tovrea III. This photograph showing the lights on the battlements hints at the picturesque moments special visitors shared while on the grounds. Those who passed by in their cars that evening must have wondered what was happening in the castle. (Photograph by Gregory Davis.)

When Philip Tovrea III lived in the castle, he often entertained visitors. During spring break 1991, members of his immediate family and a few friends gathered for relaxation and to get away from the hustle and bustle of their everyday lives. Children's voices rang throughout the halls. There were plenty of rooms as well as the grounds for them to explore. From the kitchen one could see the mountains to the east and north. On the right side of the picture is a propane gas stove. There was no gas line to the castle as Carraro had intended that the stove be electric. It is hard to imagine having a water heater visible in a modern kitchen today. Standing left to right are Jim Daniels (an attorney and family friend), R. Deryl Edwards Sr., Kate Daniels (wife of Jim), and Philip Tovrea III (brother-in-law of Edwards). (Courtesy of Philip E. Tovrea III.)

From left to right above, family and friends Jim and Kate Daniels, Royce Deryl Edwards Sr., and Royce Deryl Edwards Jr. sat around the patio fire pit, since it was ideal weather for being outside during a spring evening in Phoenix. Note the large concrete urns in the background. Carraro's vision for the grounds of his resort included a small ball court as a place where guests could try their hand at a game that was a cross between bocce and pocket ball. This would have been much too sedate a game for the young teens who, in early 1991, set up a basketball court attached to the aviary that Della placed by the patio area. At one time, Della had over 200 birds, including peacocks, on the property. The boys, Philip Tovrea Edwards (left) and Perry Ambrose Tovrea (right) are cousins. (Both, courtesy of Philip E. Tovrea III.)

TOVREA CASTLE:
Options for the Future

A Report by the
Tovrea Castle Citizen's Advisory Committee
City of Phoenix Planning Department

In August 1988, the Tovrea family trust requested a change in the Phoenix General Plan to change the zoning for the property from parks/open space to commercial. The city historic preservation commission urged its staff in September 1988 to review the possibility of placing Tovrea Castle on the Phoenix Historic Register in order to protect it. The Phoenix Planning Commission held two hearings for the Tovrea family trust's general plan amendment application. The application was approved and referred to city council in November 1988. In December, the Phoenix City Council created a citizen advisory group to study the issue and make recommendations. The general plan change appeared on the January 1989 agenda, but the council gave it a six-month continuance so the advisory group could complete its work. The resulting report provided a number of actions for the preservation of the castle. It also provided recommendations for its use. This report compelled the city to seek protection of the property by purchasing it. (Courtesy of City of Phoenix Historic Preservation Office.)

Six

A City Park

Based on recommendations of the citizen advisory group and the support of several city council members, the 1989 Phoenix bond election allocated $5 million, which enabled the city to purchase a portion of the property beginning in 1993. By 1997, the city owned the castle and 18.3 acres of the nearly 44 acres and acquired the remaining parcels by 2003.

Restoration of the cactus garden began. Volunteers from groups such as the Master Gardeners and the Desert Botanical Garden over the intervening years helped remove dead or diseased cacti, replant new cacti, install plant signs, remove weeds, and generally brought back the cactus garden to its glory.

The Phoenix Historic Preservation Commission initiated the process and placed the castle on the Phoenix Historic Register in December 1990. Subsequent city bond elections, plus other fund-raising enabled the Phoenix Historic Preservation Office to authorize the restoration of the curious castle on the hill. Because of its basic construction and deferred general maintenance over the years, the castle required extensive work before it could open to the public. Architectural drawings and engineering reports helped determine how to work with Carraro's design and bring it up to commercial standards without damaging the integrity of the building.

Several interpretive plans described the potential. Work on a master plan for the site began in 2000 and was adopted by the city council in 2003. The site received a Preserve America Grant for interpretive planning in 2008. While the efforts to open the site to the public have been long, tedious, and expensive, those who have spearheaded the charge know the public will be pleased.

In honor of the two families who are associated with this unique site, the city chose to keep the name Tovrea for the castle since that family owned it for over 60 years. Warner Heights was to become Carraro Heights following Alessio Carraro's purchase of the land and initiation for subdividing it. The park is now called Tovrea Castle at Carraro Heights.

What was once considered a rural area east of Phoenix on the Tempe Road (now Van Buren Street) and virtually isolated from any other development now has a freeway on two sides. The castle, just to the left of the freeway on the right side of the picture, sits on the highest point of the property. The visible circle just north of it is another granite knoll, leveled as part of Carraro's future development plans for the site. There is a smaller knoll just to the south that was also leveled. The large building to the left of the castle, once home to part of the Tovrea Stockyards, houses a major U.S. Postal Service handling station. Looking north, Van Buren Street bisects the top of the aerial photograph and Washington Street the bottom. To the southwest is Sky Harbor Airport (not shown). Much of the visible vacant land in this 1996 aerial is now developed. (Courtesy of Flood Control District of Maricopa County.)

There are two gated entrances to the property. The main entry point for park visitors will be from a new visitor center located just west of this Van Buren Street gate. As with many building projects, difficult economic times have impacted the dream to officially open the park, even though the castle restoration is complete. (Photograph by Donna Reiner.)

Over the course of time, a number of logos appeared on T-shirts and other items Tovrea volunteers sold during the garden tours. In April 2010, a new logo was unveiled that marks the official name of the park: Tovrea Castle at Carraro Heights. (Photograph by Donna Reiner.)

121

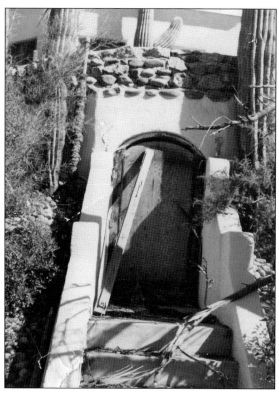

At least one of the arched tunnel doors suffered from exposure to the elements and had to be restored (left). Many areas of the castle wall exhibited severe plaster deterioration caused by water (below). Consideration on how to best water the plants closest to the castle to reduce seepage into the basement and minimize constant exposure of the plaster to water is an ongoing issue. (Both, courtesy of City of Phoenix.)

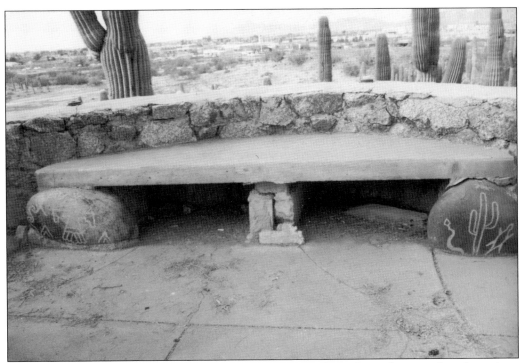

Della added the custom patio bench on the upper terrace above. It is a favorite place for visitors to pose for a photograph in part because of the scenic backdrop. It is also a wonderful place to watch the colorful desert sunsets. Over the years, one of the petroglyph rocks fell off. Fortunately, pictures of the bench in its original state enabled the workers to replicate the missing stone (below). (Above, courtesy of Marie Cunningham; below, photograph by Donna Reiner.)

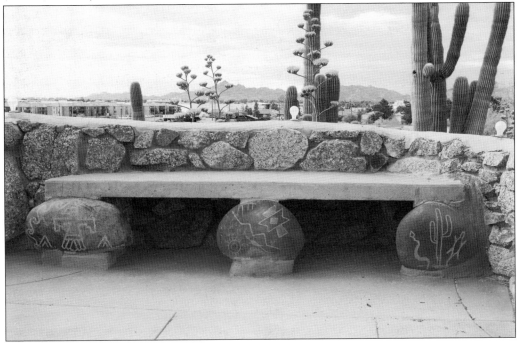

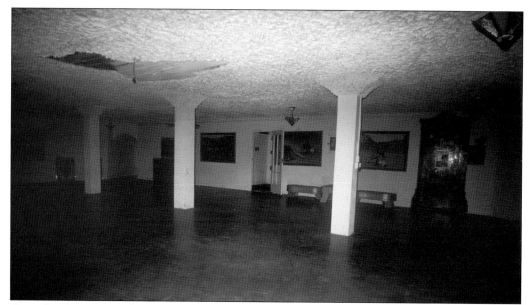

Over the years, water slowly leaked into the castle and began to damage portions of the ceilings. These 1983 photographs show some of the damage to the delicate basement ceiling (above) and the first-floor ceiling (below). Unfortunately, more extensive damage occurred before the city finally acquired the property and began the restoration process. Due to the nature of the building construction and such details as the textured walls and stenciling, the Phoenix Historic Preservation Office consulted appropriate experts. Engineering reports determined that the floors of the castle did not meet current residential standards. In order for the building to be open to the public though, the floors would have to meet commercial standards. This meant reinforcing the wood flooring and carefully inserting steel beams from one side of the building to the other. (Both photographs by Gregory Davis.)

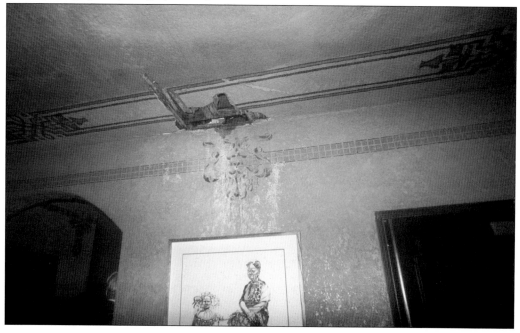

The Tovrea Roundup is a large annual private gathering on the castle grounds (above). Held in March when the weather is generally mild in Phoenix, tables of food and shade tents occupy a spot near the machine shop. Members of the far-flung Tovrea family and friends attend along with Carraro family members who still reside in the area. It is always fun to see who comes and what their relationship to the castle is. For some, it is the first visit; for others, one of many. This is a time for people to share memories of visits and stays at the castle with newcomers. An opportunity to introduce young children to a piece of their family history pointing out all the little intricacies and quirks of the castle's design. Each year the invitation provides a bit of history related to the historic castle families (below). (Right courtesy of City of Phoenix; below, courtesy of Philip E. Tovrea III.)

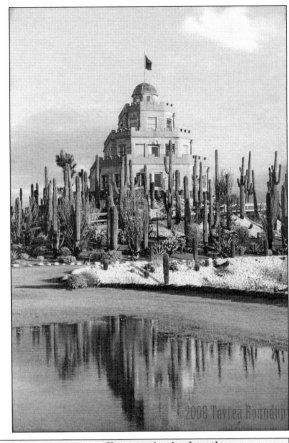

2008 Tovrea Roundup

Ed Tovrea called the O-L brand the oldest in the world. He got the idea from pre-historic Indian hieroglyphics on a rock behind which he once sought protection in a gun battle with rustlers. In 1891 he brought in the brand to the Maricopa county courthouse burned on a piece of saddle leather. Neri Osborn, county recorder, carefully noted the recording in "Book 1 of Marks and Brands Records of Maricopa County, June 11th, 1891 at 3:40 P. M."

You are invited to the
2008 Tovrea Roundup

Sat. March 15th 2008
Noon to Sunset
Potluck Pitch-In

Tovrea Castle
5041 East Van Buren
Phoenix, Arizona

Philip Tovrea III
928-634-5200
philip@unitedverde.com

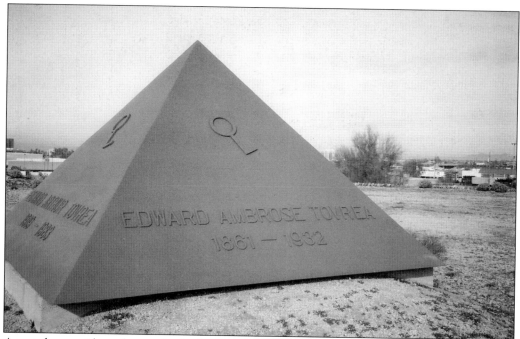

A metal pyramid on the north platform memorializes the names of four Tovrea men. Edward Ambrose (above), his son Philip Edward (below), and Philip's two sons, Philip Edward Jr. and Edward Arthur. The family brand, as seen on each side of this memorial, is the Circle Walking L. According to family lore, E. A. based it upon a hieroglyphic he discovered on a rock when hiding from some rustlers. He recorded the brand at the Maricopa County recorder's office on June 11, 1891. (Both, courtesy of Philip E. Tovrea III.)

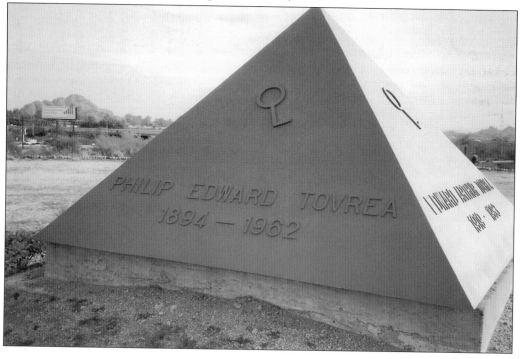

The Phoenix Points of Pride program began in 1991 to foster a sense of community pride among Valley residents. The first 25 points of pride, selected in 1992, consisted of parks, cultural facilities, historical residences, and mountain peaks. All these unique locations are found within the Phoenix city limits and contribute to the city's quality of life. The designated sites are places residents would tell their friends and visitors not to miss when in town. And certainly they would be places families might visit on an outing to enjoy Phoenix's most popular landmarks. The initial election process involved 40,000 residents voting for their favorite destinations and resources. Narrowed from 150 locations to 40 before the final 25 were selected, each site displays one or more signs to recognize the designation. Tovrea Castle was one of the original Phoenix Points of Pride. (Photograph by Donna Reiner.)

DISCOVER THOUSANDS OF LOCAL HISTORY BOOKS
FEATURING MILLIONS OF VINTAGE IMAGES

Arcadia Publishing, the leading local history publisher in the United States, is committed to making history accessible and meaningful through publishing books that celebrate and preserve the heritage of America's people and places.

Find more books like this at
www.arcadiapublishing.com

Search for your hometown history, your old stomping grounds, and even your favorite sports team.

Consistent with our mission to preserve history on a local level, this book was printed in South Carolina on American-made paper and manufactured entirely in the United States. Products carrying the accredited Forest Stewardship Council (FSC) label are printed on 100 percent FSC-certified paper.